Discover
MANGA DRAWING

30 Easy Lessons for Drawing Guys and Girls

Mario Galea

IMPACT
CINCINNATI, OHIO
www.impact-books.com

About the Author

Mario Galea is a character designer and animator living in northeastern Pennsylvania. He has art degrees from Pennsylvania State University and the Art Institute of Philadelphia. Mario works mainly in the digital medium, and is strongly influenced by Japanese animation. His work has been sold internationally, and can be seen on his website <www.mariogalea.com>.

Acknowledgments

I'd like to thank God; His consultations were very helpful. Thanks to my mom and dad for all the love and support. Thanks, Aunt Adele, for orchestrating the events that inspired this book. Thanks to Josh Menas, a great artist and a great friend. A big thank you to Pam Wissman for giving me a chance, and Christina Xenos for making publication fun and easy! Last, but not least, thank YOU for picking up this book. Get another for a friend; they'll love you for it.

fw
F+W PUBLICATIONS, INC.

Other awesome IMPACT Books are available from your local bookstore, art supply store or direct from the publisher.

10 09 08 07 06 5 4 3 2 1

DISTRIBUTED IN CANADA BY FRASER DIRECT
100 Armstrong Avenue
Georgetown, ON, Canada L7G 5S4
Tel: (905) 877-4411

DISTRIBUTED IN THE U.K. AND EUROPE BY DAVID & CHARLES
Brunel House, Newton Abbot, Devon, TQ12 4PU, England
Tel: (+44) 1626 323200, Fax: (+44) 1626 323319
Email: mail@davidandcharles.co.uk

DISTRIBUTED IN AUSTRALIA BY CAPRICORN LINK
P.O. Box 704, S. Windsor NSW, 2756 Australia
Tel: (02) 4577-3555

Library of Congress Cataloging in Publication Data
Galea, Mario.
Discover manga drawing : 30 easy lessons for drawing guys and girls / Mario Galea.—1st ed.
 p. cm.
Includes index.
ISBN-13: 978-1-58180-697-7
ISBN-10: 1-58180-697-3 (alk. paper)
1. Human beings–Caricatures and cartoons–Juvenile literature. 2. Cartooning–Technique–Juvenile literature. 3. Comic books, strips, etc.–Japan–Technique–Juvenile literature. I. Title.
NC1764.8.H84G35 2006
741.5–dc22 2005017696

Edited by Christina Xenos
Designed by Wendy Dunning
Production art by Joni Deluca
Production coordinated by Mark Griffin

METRIC CONVERSION CHART

To convert	to	multiply by
Inches	Centimeters	2.54
Centimeters	Inches	0.4
Feet	Centimeters	30.5
Centimeters	Feet	0.03
Yards	Meters	0.9
Meters	Yards	1.1
Sq. Inches	Sq. Centimeters	6.45
Sq. Centimeters	Sq. Inches	0.16

Table of Contents

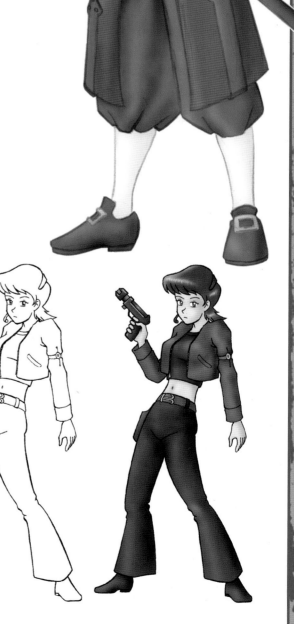

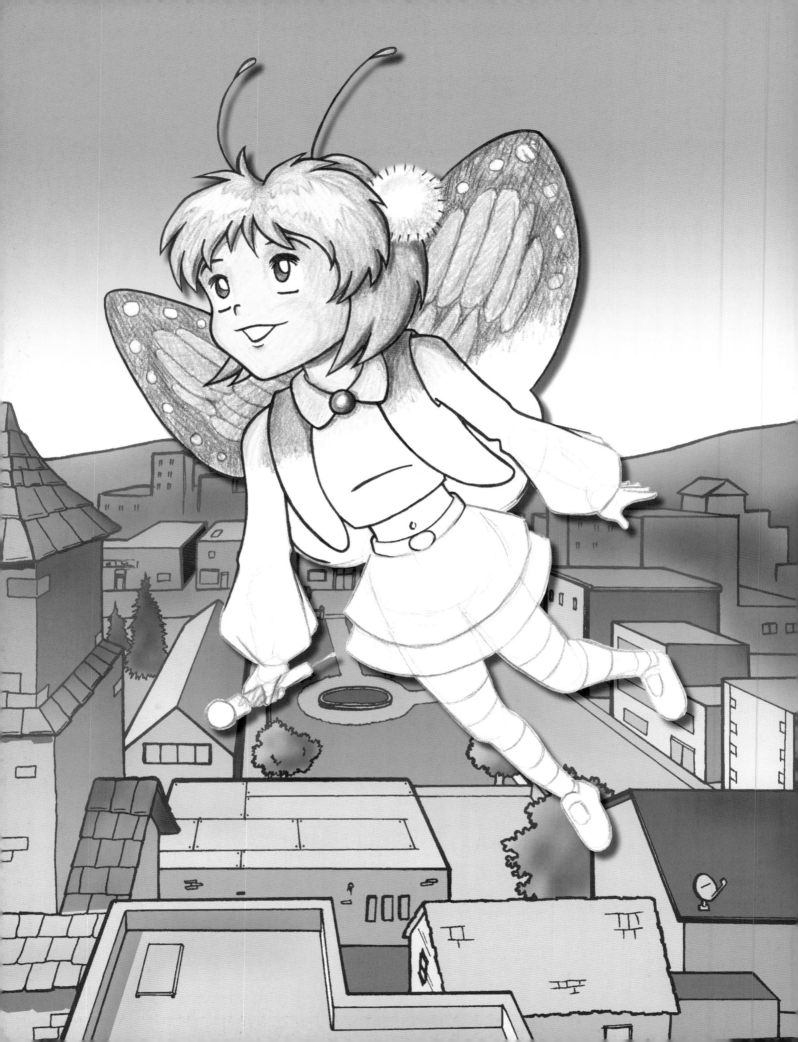

Salutations!

Welcome to the beginning of the book. The style of drawing featured here is based on popular Japanese styles of manga and its animated form, anime. Perhaps that is why you picked up this book. These days this art is everywhere—on television, in theaters and in many video games. But remember that manga and anime are not so much styles as they are a genre, and my style is offered as merely one among many within the genre.

If you can draw a circle and some lines, then I will show you how to use them. If you can't, there are books on how to draw circles and lines out there. I remember we had one in kindergarten. I hated it. Whenever the teacher passed it out, I would hide under the table.

I wrote this book so that others could learn to draw like I do, and when I have created enough clones I will be able to take over the art industry and later the world. Uhh... no, actually, that's not it.

Although these pages give step-by-step insight into my own drawing techniques, you shouldn't feel as though your drawings have to mimic mine exactly. I can, however, give you a place to start on your way to developing your own style, or if you already have a preferred drawing style, I can offer you another to compare with. You can never be too versatile. So come out from under the table, and we can create some art together.

Materials

There's a tool for every job, so let's look at some of the tools that will help make your drawing easier and more fun. Obviously, some sort of writing utensil and something to make marks on must be had, but not everything talked about here is absolutely necessary. The two important things to consider are what you feel comfortable using and what will give you the results you want.

PENCILS

A basic number-two pencil is all you need to get started. Of course, pencils vary in hardness. The softer the pencil, the darker and heavier the line will be. For our purposes, you don't want too dark a line so you can still erase parts of the drawing that you don't need. A pencil labeled HB should provide just the right line weight.

OTHER PENCILS

A nice thing to have is a mechanical or technical pencil. It will give you a clean, precise line. But be careful: That's not always such a good thing. The ideal line, in most cases, is an expressive one that varies in thickness.

Many professional artists use color-erase pencils, especially in the animation industry. Typically, they come in either red or blue, and make easily erasable lines. The red or blue color takes don't show up when you photocopy or scan your paper. When the image is shot, only the ink lines show up. This is the kind of pencil I usually use.

PAPER

If you're like me, you like to doodle in the margins of your notebook and on any scrap of paper you can find, and that's OK. However, when you want to do some serious work, please leave the lined paper behind. You don't want ledger lines running through the work you ought to be proud of. Simply use ordinary 20-lb. (40gsm) letter-sized 8½" × 11" (22cm × 28cm) paper, the kind you can find in any office supply store. It's cheap and usually all you really need. If, on the other hand, you would like to do some more serious artwork, such as making your own comic books, try something more substantial. The professionals typically use 100-lb. (210gsm) tabloid-sized 11" × 17" (28cm × 43cm) bristol board, found in many art supply stores.

PENS

As your drawings improve, you will definitely want to invest in a set of good inking pens.

Find a set that gives you a wide range of sizes or line weights. Be careful of the pens you choose; depending on the pen and the paper you apply it to, some bleeding or smudging may occur. My favorite pen is a size 005 Pigma Micron pen, but that may change in time. You shouldn't be afraid to try different types to find out what you like best.

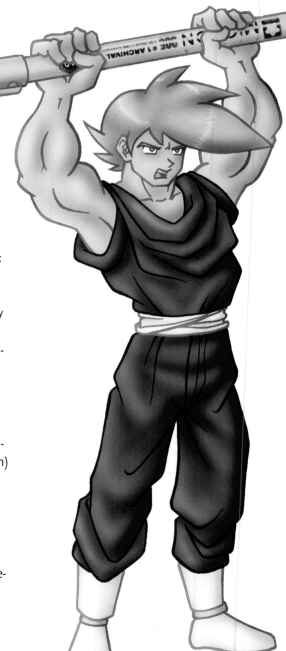

ERASERS

If you think being a good artist means never having to erase, don't kid yourself. Artists do lots of erasing, and there are different erasers for different tasks. The small eraser you may have on the end of your pencil lends itself to correcting small mistakes in tight corners; however, for a larger area, you need a larger eraser. A white vinyl eraser works well and doesn't eat away at the paper as much as a pink rubber eraser. But for real control, I recommend the kneaded eraser. It is a hunk of pliable gray rubber that can be molded into various shapes for different effects. You keep it clean by stretching and folding (kneading) the rubber.

COLORED PENCILS

If you want to bring color to your drawings, the easiest way is with colored pencils. Softer pencils blend well to create subtle shadows and highlights. They are ideal for beginners because of their ease of use and lower cost.

MARKERS

My mother says don't use markers or you'll ruin the good furniture. But my mother isn't writing this book; I am. So take a look at different sets and try them out. Just be aware that some markers do bleed across and even through paper. Also take care not to work on one area too much, as you will oversaturate the paper and could end up tearing a hole in it. A good set of

design markers can be expensive, but they can give your work a clean, finished look to be proud of, if you're very careful.

WATERCOLORS

Some manga artists achieve impressive results using watercolors over their pencil work. If you have little experience with manga, then perhaps this is best left until you are more confident. But if you do try it, remember to use special watercolor paper.

STRAIGHT EDGES

Although figure drawing should be a more free-form expression, there will be occasions when you desire a perfectly straight line. A simple ruler may work fine, but also consider using a drafting triangle for help creating perpendicular lines.

COMPUTER SOFTWARE

By no means is a computer necessary to create great art. With that said, we live in a technological age, so I'd like to make mention of it here. You can use any decent computer with a scan-

ner to enhance your inked drawings. Most professionals use a program called Adobe®Photoshop® in their work, which comes at a hefty price. There are less expensive products available, but they have fewer features. Many books have been written to teach Adobe®Photoshop® techniques, so I'll mention only a few pointers. Scan your inked images in bitmap or line-art mode, scan at a high enough resolution (200 to 300 dpi) and learn all the possible ways the program offers for selecting pixels.

Basic Drawing Advice

For now, if you have at least a pencil and paper, we can get ourselves ready to work. First, I'll ask you to consider the following tips for making the experience a pleasant and fruitful one.

Some people say artists must suffer for their work; nevertheless, your own comfort plays a critical role in the production of good art. This means finding the right environment in which to work. You will need to draw on a sturdy, flat surface. Some artists prefer to work on a surface that tilts toward them. You can find a drawing board or art table like this in any art supply store, but your kitchen table or coffee table may suit you just as well. It's all about feeling comfortable. This comfort

also extends to your eyes. Having to strain to see the details of your drawing certainly isn't beneficial, so that makes working in a well-lit area a must. One other part of your environment worth considering is what you can hear. Try to reduce noisy distractions, or play some of your favorite music. Listening to an inspiring tune can do wonders for your creativity!

When you are actually drawing, try to think about how you make your lines. Stay loose, and keep a light touch in the beginning of each drawing. Don't think that the first marks you make on the page have to be permanent. Your grade school teacher probably taught you the same thing when you learned to write. I remember we practiced making ovals and sweeping lines in penmanship class. The same is true here. If you are a raw beginner, I suggest spending time just tracing some of the examples

in this book. This will train your hand to make the necessary movements needed for this particular type of drawing.

Last, but not least, be observant. In the same way that a writer must continually read to improve his craft, so too must a visual artist look at other art. So watch your cartoons and read your comic books, and do so with an artist's eye.

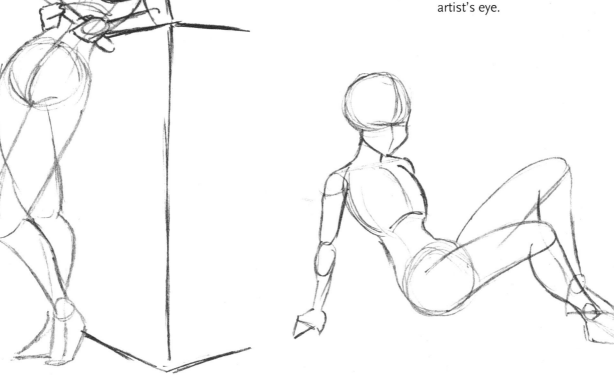

9

Inking

Once your pencil drawing looks the way you would like it, you will probably want to ink it so that it will appear more finished. Inking takes skill and patience. In the professional world, there are artists who specialize in inking, and that's really all they do. So don't feel bad if you can't get the hang of it right away.

Just Relax

When inking, it is important to be relaxed. If you tense up, your hand will shake, and the clean line you want will be a jagged mess. Try to move the pen in smooth, natural strokes. Best results come from using the natural movements of your fingers and wrist; therefore, turning the paper to find just the right angles can be helpful.

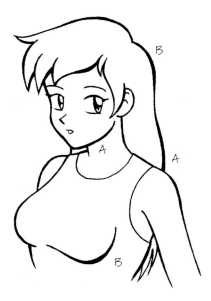

Pen Types

There are many types of ink pens from which to choose. Some allow you to change the line thickness by varying the pressure, and others come in sets of different line weights. Whatever you feel comfortable using, the desired outcome is the same: clean lines with varying line quality (or thickness). A good rule of thumb is to simply use a heavier line in areas that are in shadow (A) or are rounded outward (B).

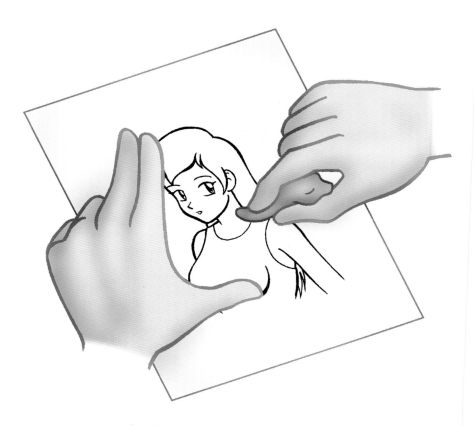

Cleaning Up

Make sure that the ink is dry first, and then use a kneaded eraser to remove your pencil lines. **BE CAREFUL.** Heavy areas and the ends of line strokes are usually the last to dry completely. Also, if you get overzealous, you may end up tearing or wrinkling the paper. Try framing the area you are erasing with the thumb and index finger of your other hand. While holding down the page this way, stroke the eraser lightly on the paper between your thumb and finger.

Shading

Although manga is traditionally printed in black and white, inking the outline of your drawing may be only part of the finishing process. You can give depth to your creation by adding color and shading. There are many different styles of doing so. I'll show you just a few.

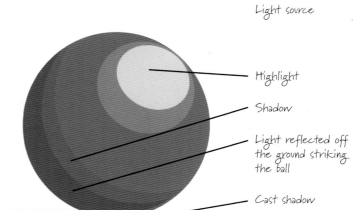

Light source

Highlight

Shadow

Light reflected off the ground striking the ball

Cast shadow

Discovering Depth
The gradation from light to dark may be hard or soft, but the main thing is that it is consistent. This means that all the shadows and highlights must be in correct relation to the light source.

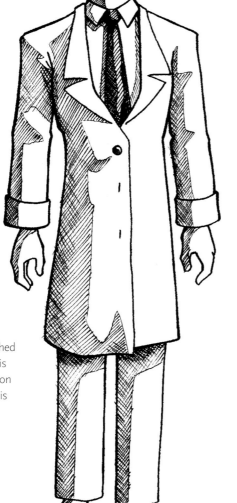

Crosshatching
Shading can be accomplished through crosshatching. This method really is an extension of the inking process, as it is done with a pen.

Halftone Screen
Another printer-friendly shading technique is called a halftone screen. It involves cutting and placing areas of plastic film printed with a pattern of dots or lines. Today, this can be done with a computer.

Using Color

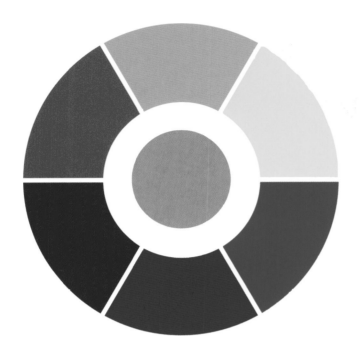

Using a Color Wheel
Color, or hue, is often represented by the color wheel. When dealing in pigments, red, yellow and blue are often referred to as primary colors. The colors between them, obtained by mixing the right amounts of the colors on either side, are known as secondary colors. Colors that lie on opposite sides of the wheel are complementary colors. Mixing complementary colors in the right amounts gives you a neutral gray, represented by the circle in the middle.

Value
Value is a measure of how light or dark a particular hue is.

Saturation
Saturation characterizes the intensity of a hue, or how gray it is.

KAWAII!
This is the Japanese word for cute, and cute is what it's all about. In Japan, ideal beauty is measured in cuteness. Keep this in mind when designing attractive characters.

Solid Color
In most anime, cells are painted in solid blocks of color. This makes it far easier to animate.

USE COLOR TO CREATE EMOTION

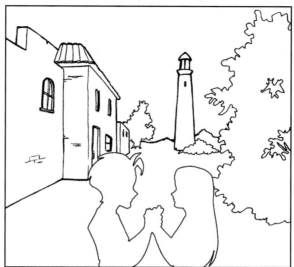

No Color

The choice of color palette can go a long way to establish mood. Consider this uncolored scene. It evokes little emotional response from the viewer. It is neutral. Now see what happens as soon as we add color.

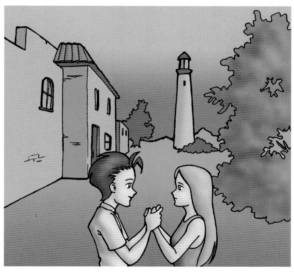

Warm Color

All of a sudden, it is a warm summer evening filled, perhaps, with romance. But what if we had chosen a different set of colors?

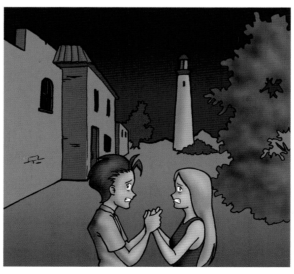

Cool Color

Now we see something completely different. It is a cold and fearful night. The same scene with contrasting color schemes gives us two different moods.

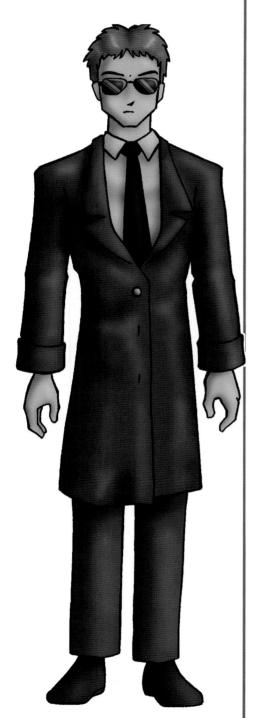

Soft Edges

Color and/or shading can be applied with softer edges using a variety of media, from airbrushes to pencils.

1 HEADS

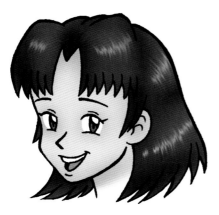

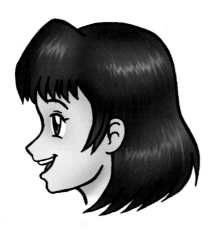

Now is the time to get excited. We are about to start drawing some real manga. In this chapter, we will be concerned mainly with drawing heads. You will learn how to construct a character's head from three main points of view, and then you'll find out how to breathe life and feeling into your creations through facial expression.

Drawing Eyes

One of the most distinctive features of a manga character is the eyes. You can sense a wide range of emotions just by looking into someone's eyes, so it is easy to understand their importance. Let's take a closer, step-by-step look.

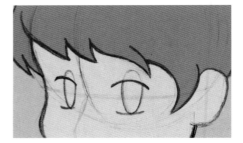

1 It's a good idea to sketch a horizontal line across the middle of the head to show where the eye level is. Make the tops of the eyes two evenly spaced arcs just above the eye-level line. The bottoms of the eyes go just below the line. The top of the eye should be at the same level as the top of the ear.

2 Add the irises (the colored parts) to the eyes. Whether you make them vertical ellipses (stretched circles) or more circular shapes, notice that the bottom edges rest tangentially to (that is, touch at only one point) the lower lids of the eyes and the tops of the irises are partially obscured by the upper eyelids.

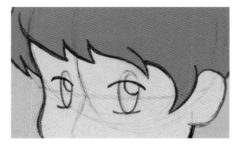

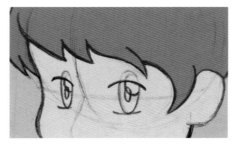

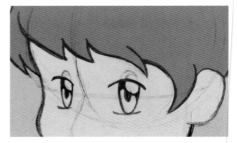

3 Add a smaller oval near the top of each iris. Make sure the ovals are off-center. These will be highlights—the reflective shine of the eyeball.

4 Add a smaller, narrower oval in the center of each iris. This oval is the pupil; it and the highlight should overlap slightly.

5 Darken the pupils where they lie outside the highlights. Next, add some shadow on either side of each pupil.

6 Create the final details, such as eyelashes, lids and eyebrows. Also, notice how the bridge of the nose makes a sweeping curve into the eyebrow. You don't have to add this to your drawing, but it is good to be aware of because it will help you create a more natural-looking relationship between eye and nose. This way it doesn't look as though you just threw the nose in anywhere.

Gallery of Eyes

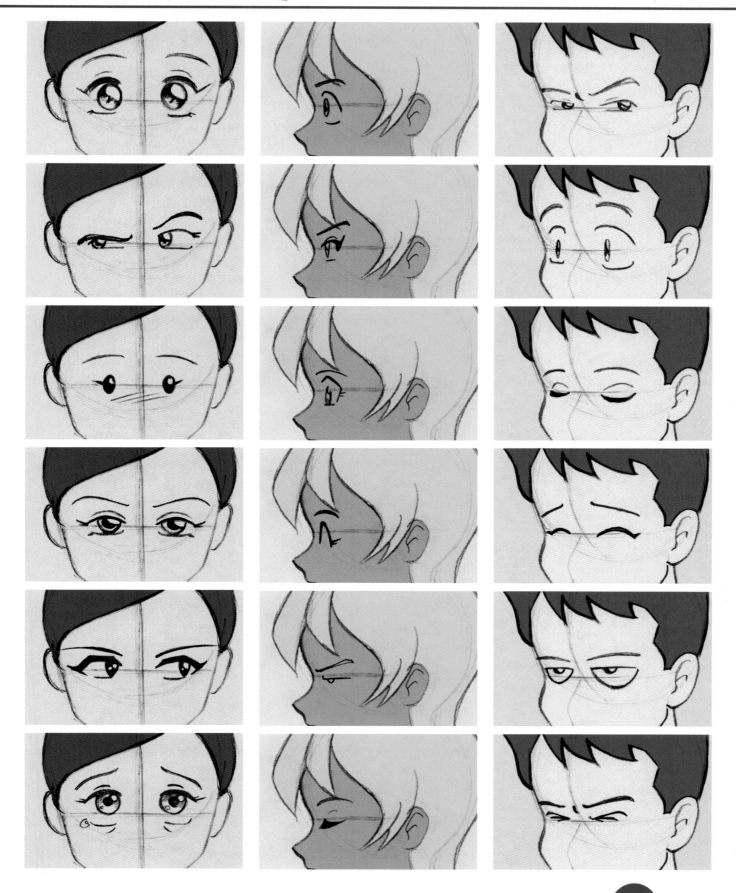

Creating Hair

When creating your character, there is a virtually unlimited selection of hair-styles from which to choose.

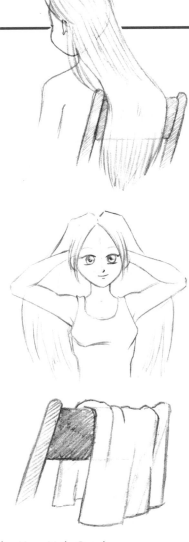

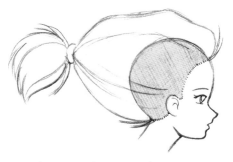

Attach Your Hair to a Scalp

All the hair on a head is attached to the scalp. It grows out from the whole scalp. This may seem like an obvious statement, but you need to think of this when deciding how the hair should hang. As in the drawing, above left, each strand starts from someplace on the scalp (the shaded area). This becomes evident when the hair is lifted up in back.

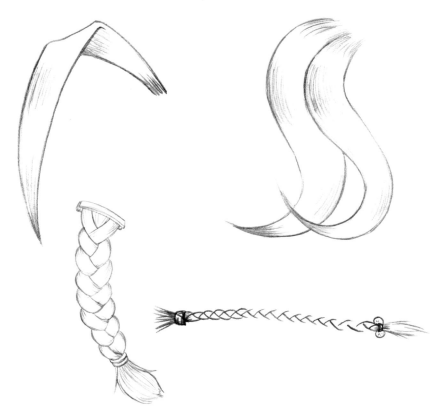

Give Your Hair Gravity

Like clothing, hair—especially long hair—is affected by gravity pulling down on it. Long hair also may flow over solid objects like the shoulders, the same way a cloth may drape over a chair.

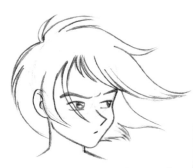

Draw Hair as One Shape

In general, hair does not get drawn one strand at a time, but rather in one or more shapes, like these. The texture of these shapes gives them the appearance of being made up of individual hairs. Notice that the texture points in the same direction as the flow of the hair.

Have Your Hair Follow the Wind

Another important factor to consider is the wind. If wind is blowing the hair, all of it should be moving in the same direction.

Hair Color

It's not uncommon to find unnatural colors in anime, such as green or purple—but why, when most Japanese people have dark hair? Keep in mind that traditional manga is published in black and white. Many readers don't know what color a character's hair is supposed to be until the animated version is released. Combine this with the fact that Japanese color terms tend to be very different from those of the West, and you end up with a wide palette of sometimes unexpected shades. Some sources associate different hairstyles and colors with personality traits; then again, some hair colors seem to have been picked at random. I'll show you some of these associations, but in the end, you should just go with what feels right.

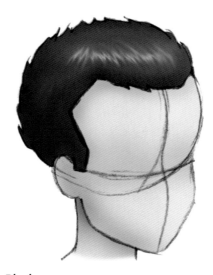

Black
Suggests a regular, more traditional character.

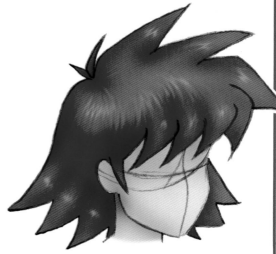

Red or Orange
Shows a wild and energetic personality, especially if it is spiked or wild in style.

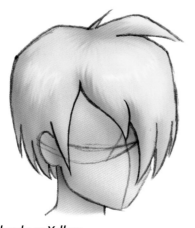

Blonde or Yellow
Indicates that the person is trouble, either intentionally or not.

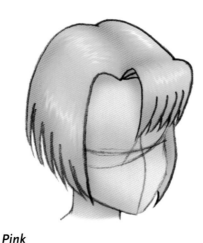

Pink
Often is associated with gender confusion, such as a tomboy or a girlish male.

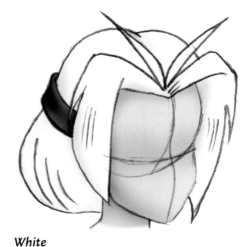

White
Traditionally belongs to the supernatural world. In Japan, it's the color of mourning and demons.

Face, Forward-Looking

When you're learning to draw faces, it is always best to start with a front view. It is usually the simplest to envision, and if you can draw one side of something, you should be able to draw the other. So, think positive! These steps also will introduce you to some of the key ingredients that go into head construction.

FROM GRAFFITI TO BOOKS

Manga as an art form has been around for centuries, appearing on the walls of Japanese temples. Today it is printed in the form of Japanese comic books.
The word **manga** *literally means "whimsical pictures."*

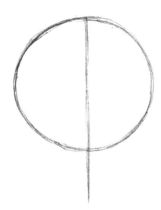

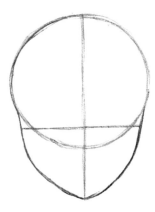

1 Start by drawing a circle. Keep it light and loose. Now divide it in half vertically, and extend the line beyond the circle roughly the same length as the radius (the line that runs from the middle of the circle to the edge of the circle). This line is the height of the entire head.

2 Draw curved lines from both sides of the circle down to the end of the vertical line. This is the jaw line and chin. Next stretch a horizontal line between the top ends of the jawline. This is where you will place the eyes.

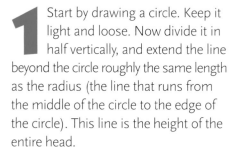

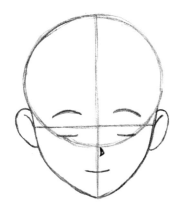

3 Draw the tops of the eyes as two evenly spaced arcs just above the eye-level line. The bottoms of the eyes go just below the line. Add the nose and mouth on the centerline. The nose can be a small pen stroke or triangle. The top of the ear should be at the same level as the top of the eye, and the bottom of the ear around nose level.

4 Add the irises to the eyes, and don't forget the eyebrows on top of the eyes. Darken the pupils and put in some highlights. There are lots of other details you can add, such as eyelashes, lids and wrinkles or folds of skin. Different styles of manga emphasize different details—you'll no doubt have your own preferences.

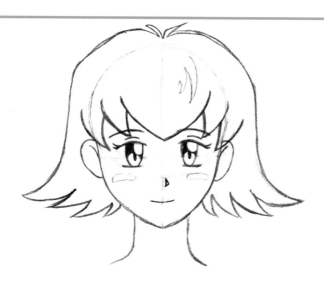

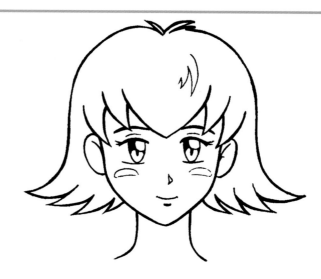

5 Hairstyles vary widely, so why not be creative? First think about how the hair will frame the face, and then build the rest of the hair around that. Oh, and just so your head doesn't appear to be floating through space, add a neck and shoulders.

6 Now you can clean up the construction lines and ink your drawing. If you're not happy with the way yours turned out, don't worry; it may take more than one try—it may take more than thirty tries. If you are satisfied with your work, try it again anyway. You can always do better.

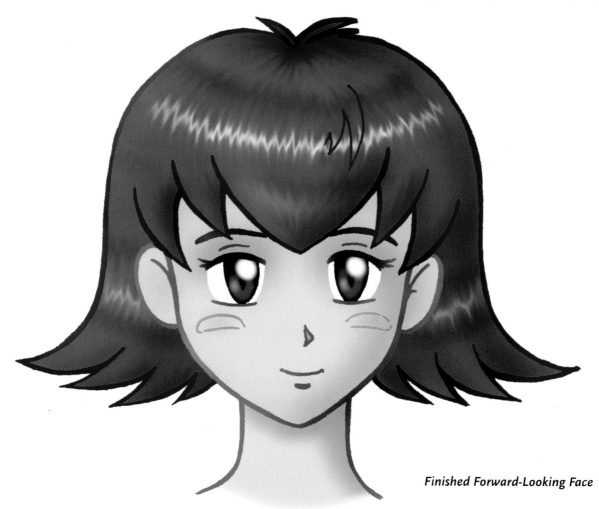

Finished Forward-Looking Face

Face, Three-Quarter

This point of view is a little more difficult than a forward-looking face. However, once you learn how to draw it, the three-quarter face will be your new best friend. You'll use it often because it is a more natural-looking pose.

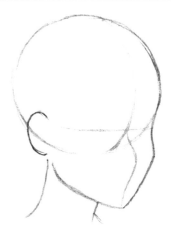

1 Draw a round shape. Think 3-D; this is not a circle, but a sphere. As with the forward view, divide the sphere in half vertically, but since your sphere (which is really your head) is turned to the side, the centerline becomes a curve. Next, add the jawline and chin to the bottom of the sphere.

2 Split this shape down the middle just like the sphere. Then sketch in the eye line so you'll know where the eyes go. Place the ear at the top of the jawline; the back of the neck also slants downward from this point.

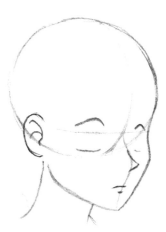

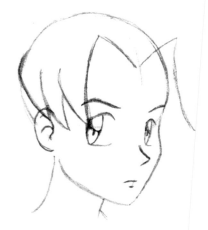

3 The top and bottom parts of the eyes appear just above and below the eye-level line. Notice that one eye is drawn narrower than the other. That is because it's on the far side of the face, and it is curving away from you. (Remember, you're thinking in 3-D.) The nose extends out from the centerline, with the mouth right below.

4 Add irises, pupils and highlights and then start framing the face with hair.

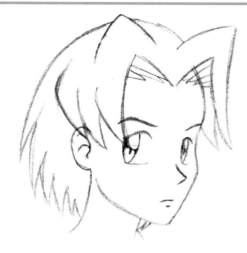

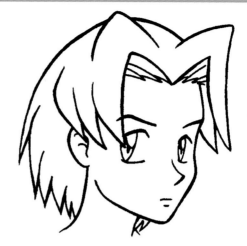

5 Add the remaining hair, and you're finished!

6 Darken your lines and erase any pencil lines. If this face was tricky to draw, keep practicing the first few steps and they eventually will become second nature. I promise. Once you get the hang of thinking in 3-D, even your forward-looking faces will have more depth.

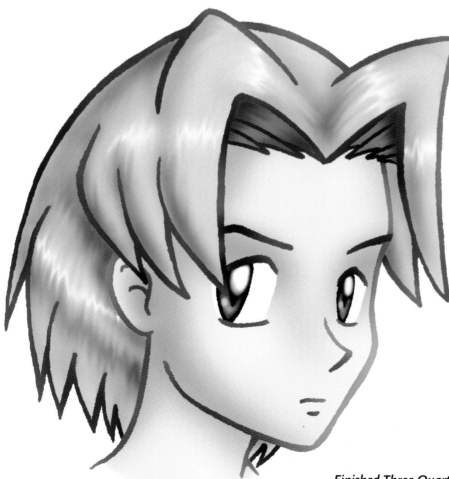

Finished Three-Quarter Face

Face, Profile

The good news about a face in profile is there is only one of everything: one eye and one ear. The bad news is the structure of the face is much more important. You need to have a good structure so your character can be easily recognized by a silhouetted face in profile.

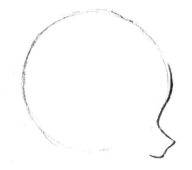

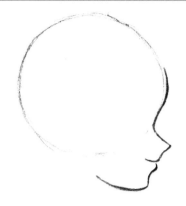

MANGA FOR ALL

In Japan, manga as a literary art form is taken more seriously than the comic books of Western countries are. It is not just for children. People of all ages read manga relating to a wide variety of subjects. In Japan it would not be uncommon to find a serious economics book written in a manga format.

1 From this point of view, it will be easy to see how your beginning circle (or sphere, if you like) forms the top of the skull. Start outlining the shape of the face from top to bottom. The forehead follows the edge of the circle about two-thirds of the way down. The bridge of the nose slopes away from the face and comes to a point. Then the line curves back in to form the upper lip.

2 Define the lower lip with a small curve just below the mouth; curve inward and back out again. Notice how the chin protrudes a bit. The line ends with the jawline curving up toward the top of the head.

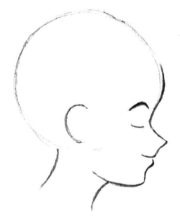

3 The eye gets placed between the forehead and nose. Even though hair or a hat may hide the ear, it's a good idea to sketch it anyway for reference; you can always erase it later. It goes above the end of the jawline; the top of the ear lines up with the eyes, and the bottom with the nose.

4 Are you getting better at drawing hair? Sometimes it helps to think of hair as one or more solid shapes. Just sketch an outline first.

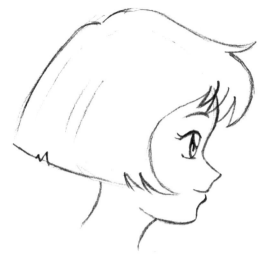

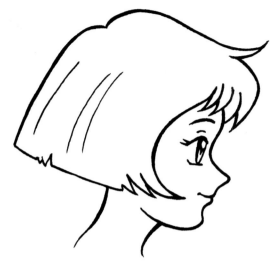

5 Once you have the overall form drawn, you can add the details like bangs and shine.

6 Darken your lines and erase any construction lines. If you are not used to it, drawing a profile outline can be difficult. Remember to break it down into its individual parts. With practice, you can achieve the proper proportions.

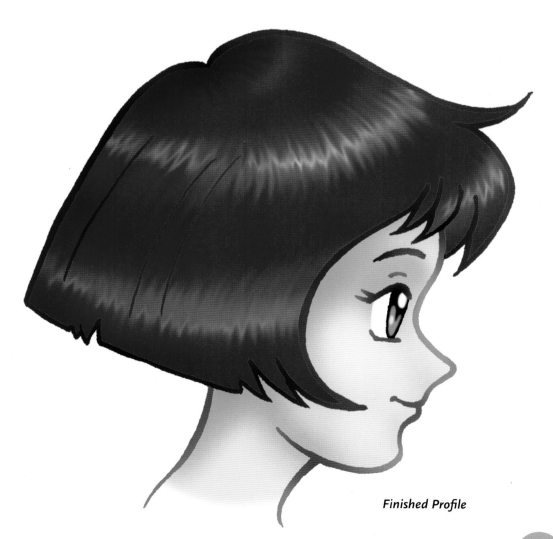

Finished Profile

Face, Other Angles

Here is a quick look at drawing the head from more dramatic angles. The trick here will be thinking 3-D and being able to rotate the basic construction shapes in your mind's eye. This may take some getting used to.

There are infinite angles from which to draw, but once you are proficient at rotating objects in your head, the process will become easier. Then you can handle drawing heads from any point of view.

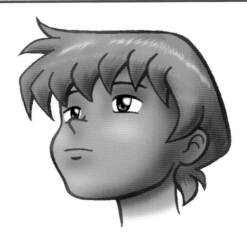

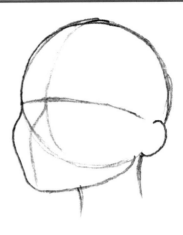

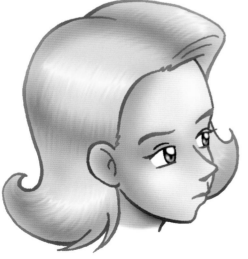

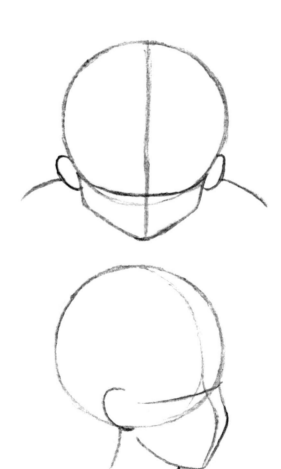

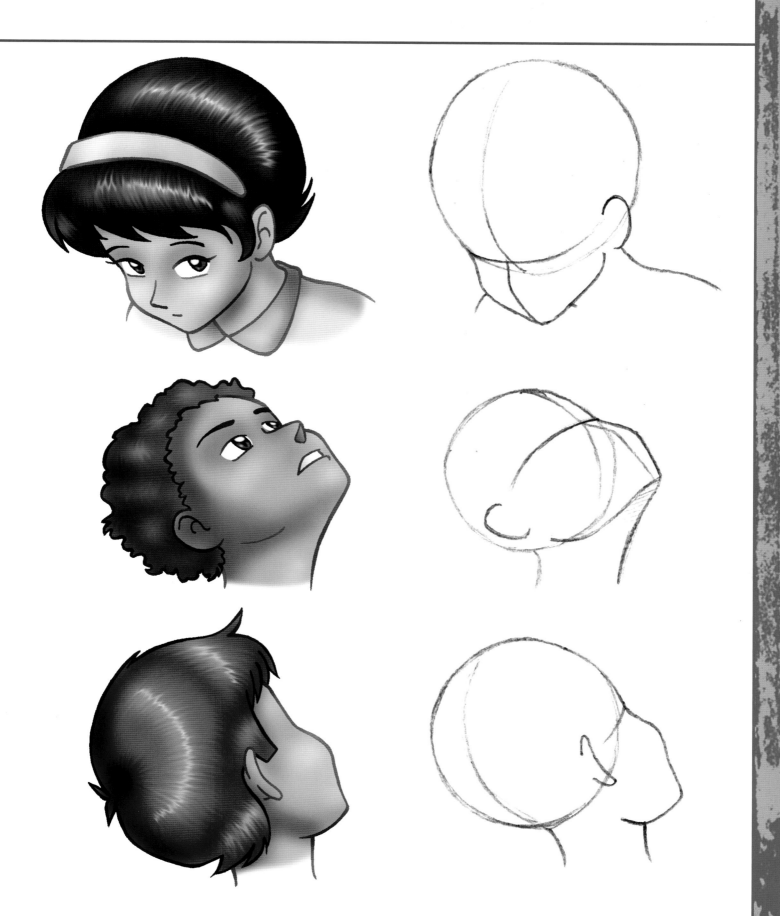

Expressions

Pleased

If you want the characters you draw to stir any emotion in the viewer, then a firm grasp of facial expression is imperative. Many artists study their own faces in a mirror when trying to capture a particular look. Creating an expressive face is mostly about understanding the muscles around the eyes and mouth. In the following examples, pay close attention to the interplay between these two areas.

This is a standard, almost neutral expression. The character is neither overly happy nor anxious. The subdued grin indicates some little thing has somehow satisfied these characters.

FAN ART

If you are a fan of a particular manga, then you might like to create your own comics based on the real thing. Amateur art of this nature is known as **doujinshi** *(doh-jeen-shee), and is quite popular. Roughly translated, it means "same stuff, different people."*

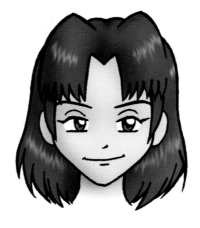
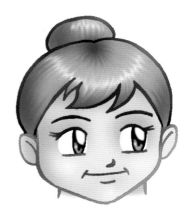
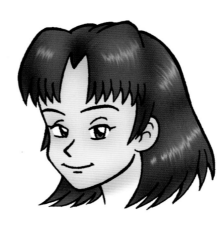
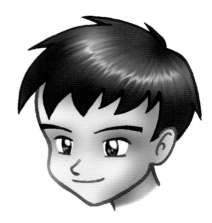

Expressions

Amused

In a happy smiling face, the upward spreading of the corners of the mouth pushes the cheek area below the eyes upward as well.

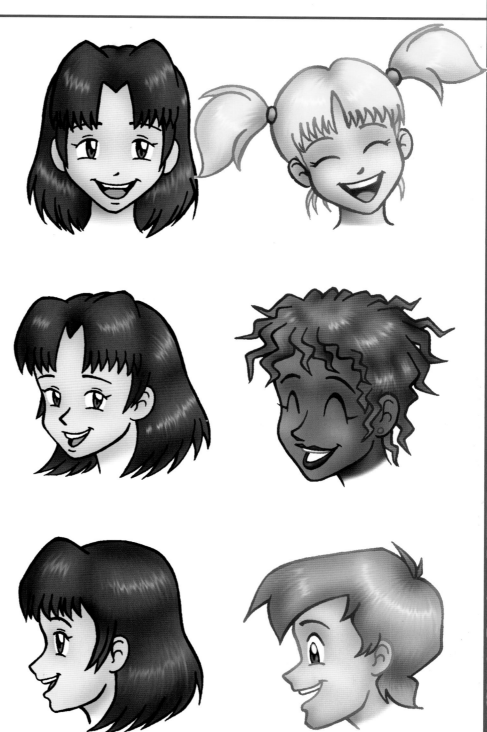

Expressions

A character looks excited because his eyes are wide open, eyebrows are raised and the mouth is gaping. Draw the irises small to emphasize the wideness of the eyes.

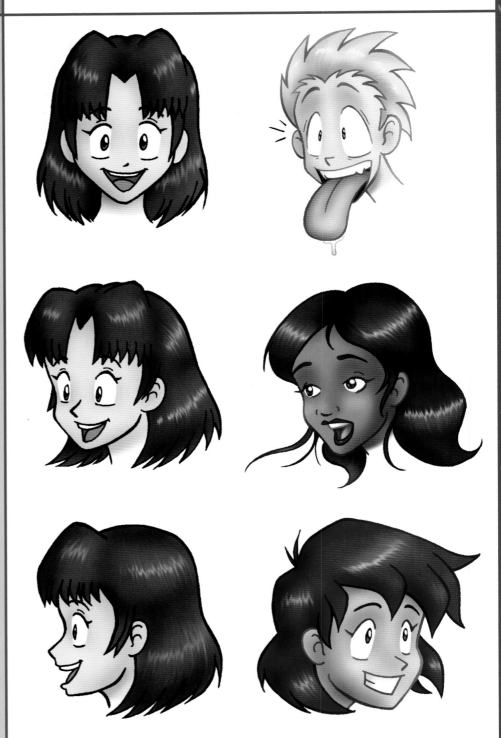

Expressions # Irritated

In an irritated expression, the eyelids droop, and the eyebrows either are horizontal or slant inward some. The eyes may be caught in midroll, as if the character is looking off to some distant spot trying to remain calm. The look is completed with a slightly pouted mouth.

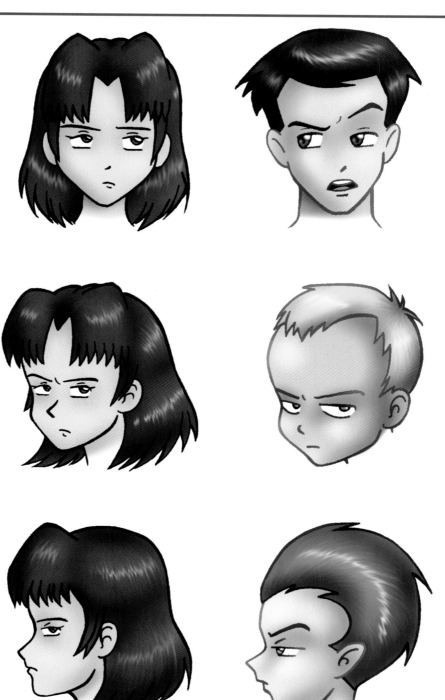

Expressions | Angry

You can show anger by slanting down the middle of the forehead. Notice the little buckle between the eyebrows. Clenched teeth also indicate anger. However, you do not need to draw individual teeth. Draw them as one shape.

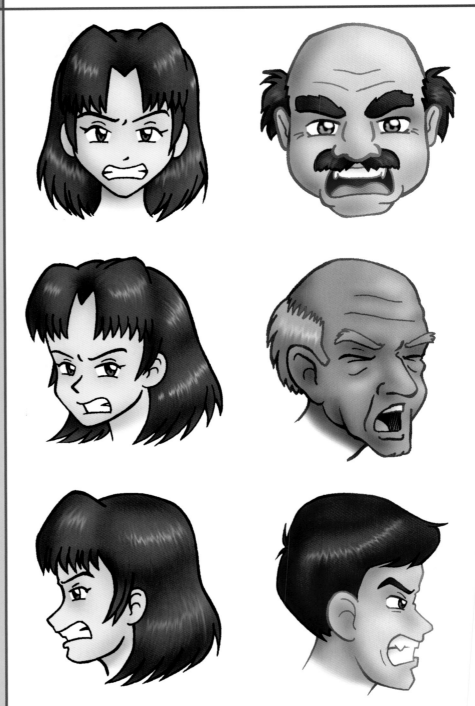

Expressions

Surprised

When your character is surprised, his eyebrows are raised, his eyes widen and the irises appear smaller. An open mouth completes the picture.

FACE FAULTS

If you really want to emphasize shock or surprise, take the expression to its extreme. This is often called a face fault, and is accompanied by exaggerated features like bulging eyes and a dropped jaw. In manga, a face fault usually results in the character falling on his face.

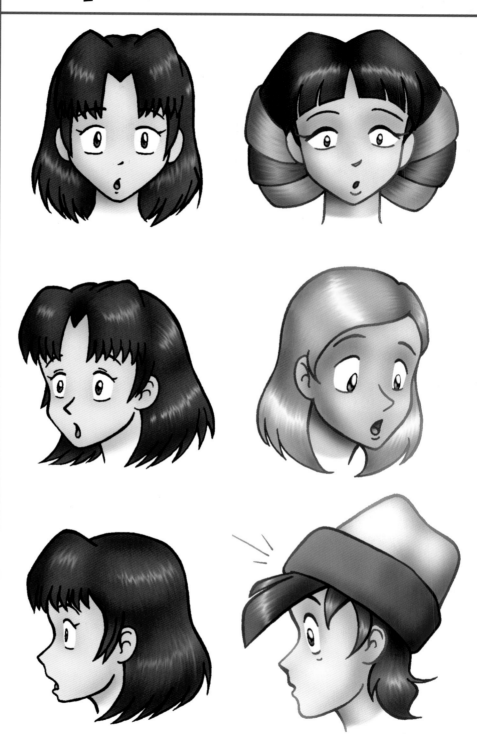

Expressions | Frightened

When frightened, a character's eyes widen, and the middle of the forehead scrunches upward. The corners of the mouth push downward; some people may bite their lower lip.

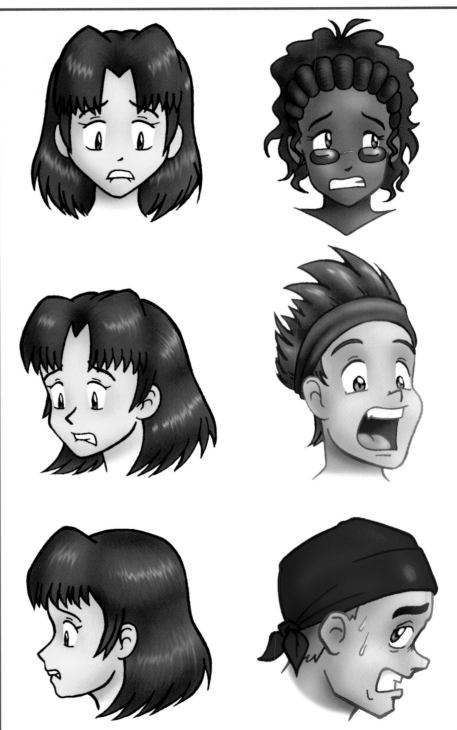

Expressions | Sad

Draw a sad expression simply by raising the middle of your character's forehead. Frowning has the opposite effect as smiling on the cheek area. Don't be afraid to show tears. Oversized irises evoke a feeling of pity in the viewer for a little extra punch.

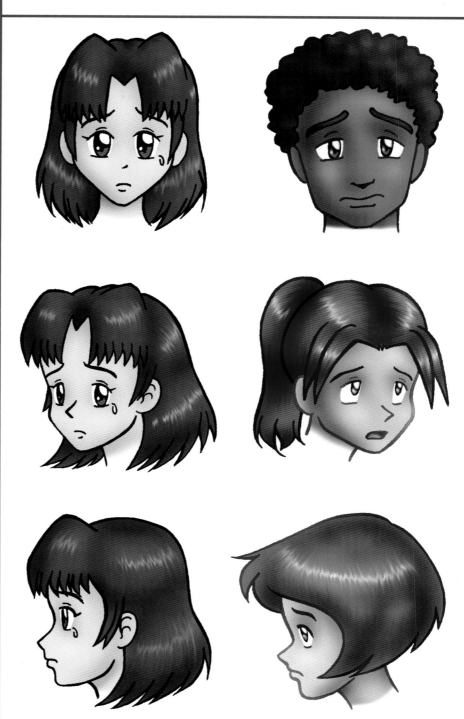

Expressions

A mischievous character is up to no good. Draw your mischievous characters with partially closed eyes that have eyebrows with a slight downward slant. Create the mouth with a crooked smirk.

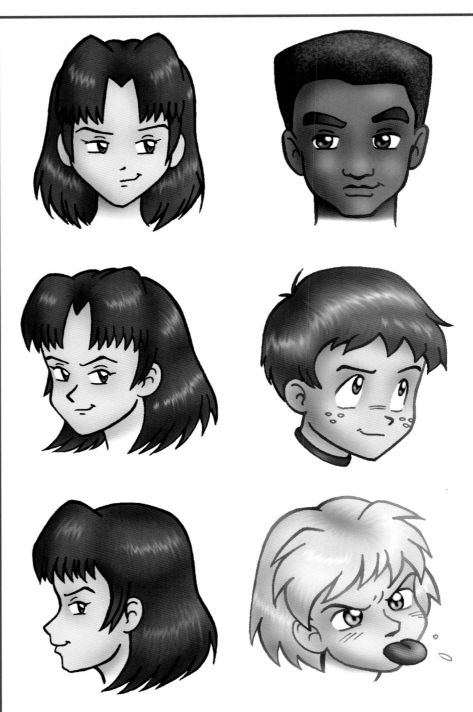

Expressions

Alluring

Make this "come hither" look by drawing slightly closed eyes, a wide grin and a sideways glance at the object of affection.

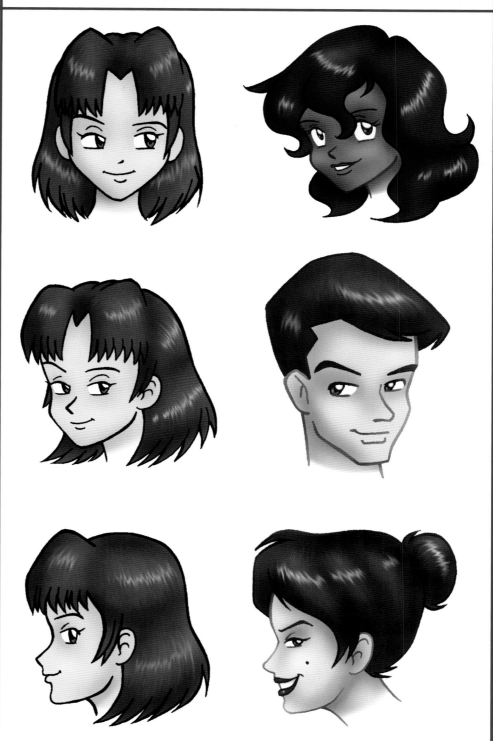

Expressions | Tired

Achieve a tired look by drawing the eyes nearly shut—the irises seem to want to roll back under the lids. Little "bags" under the eyes really emphasize the look. Notice the limp mouth on each character.

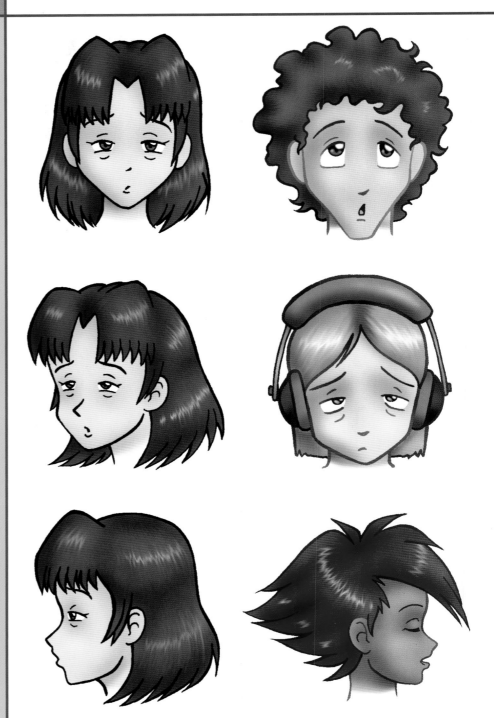

Embarrassed

Have you ever just wanted to crawl under a rock? The embarrassed character's eyes are turned away. Either she is afraid to make eye contact, or she'd rather not show her face. Here the brows can go way up. Don't forget to add some blush to the cheeks. A blush, more than any other detail, gives away the feeling of embarrassment. A few hatch marks convey blushing just fine if you are working in black and white. As for the mouth, you have some room to experiment. Often a big sheepish grin will do the trick, or try a small rounded mouth.

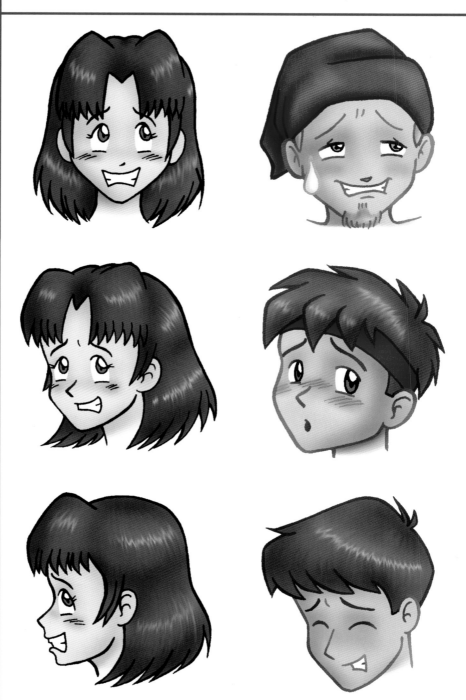

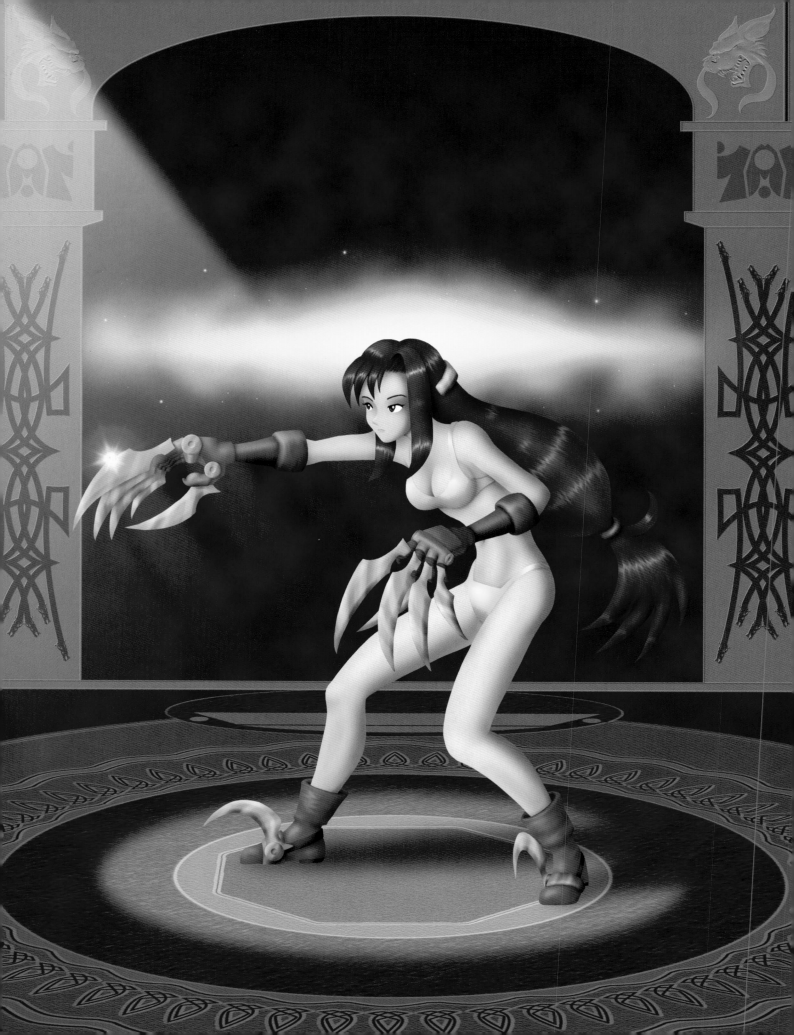

2 BODIES

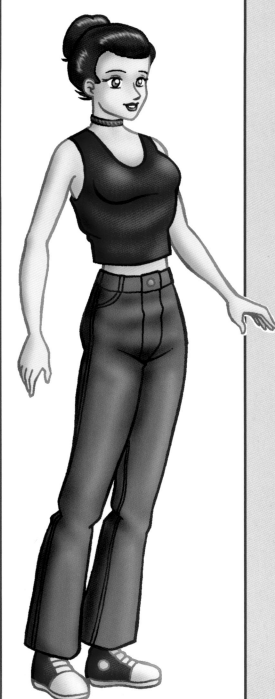

Now that you've got your heads straight, it sure would be nice

to have something for them to rest on, like shoulders or a

whole body. In this chapter, we'll examine what goes into

the construction of a human figure from an artist's stand-

point. We'll take it a step at a time.

Anatomy

I'm sure your drawing hand is itching to get moving, but before we do any more drawing, let's take some time to look at a few important body parts. You know the ones I mean...BONES and MUSCLES! Here is just a brief overview of the basics. For a more in-depth study, try looking at an artist's anatomy book.

BONES

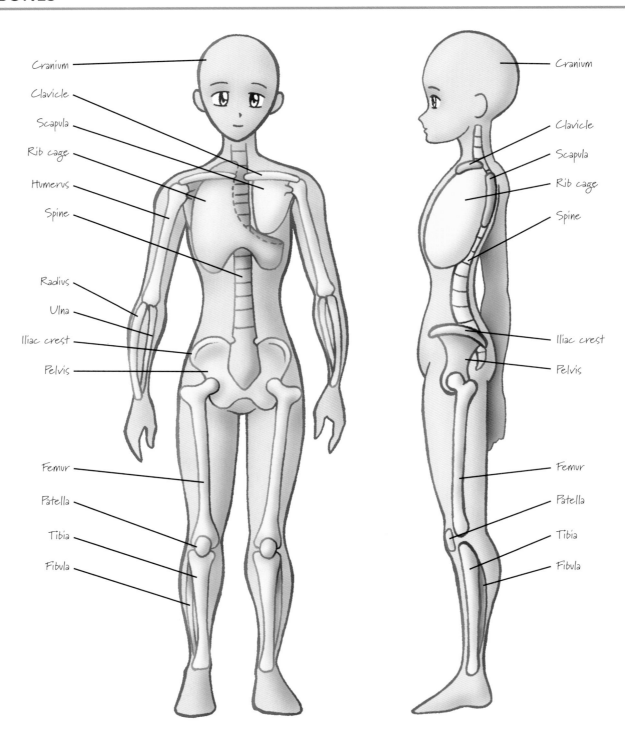

Cranium
Clavicle
Scapula
Rib cage
Humerus
Spine
Radius
Ulna
Iliac crest
Pelvis
Femur
Patella
Tibia
Fibula

Cranium
Clavicle
Scapula
Rib cage
Spine
Iliac crest
Pelvis
Femur
Patella
Tibia
Fibula

MUSCLES

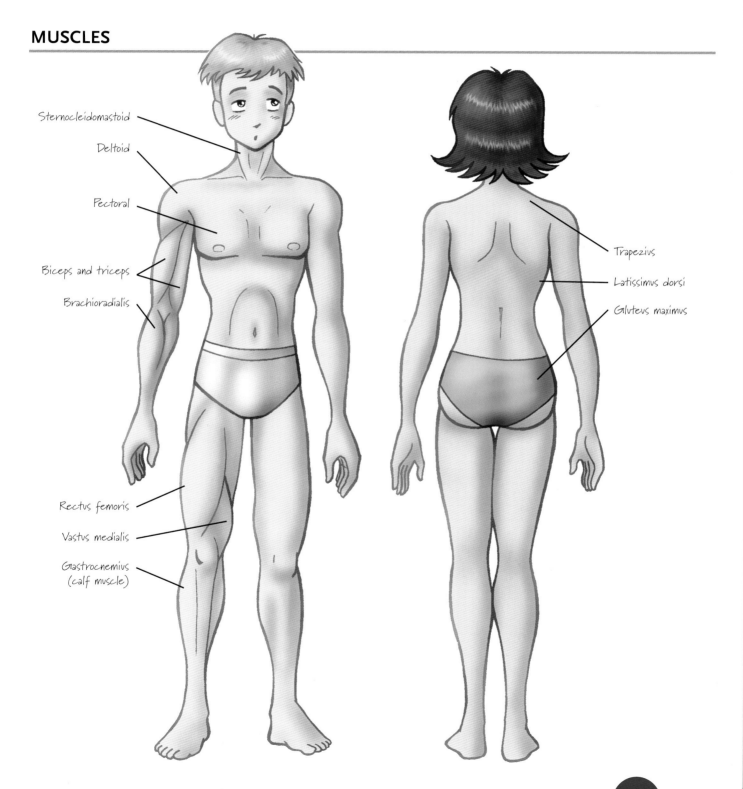

Sternocleidomastoid

Deltoid

Pectoral

Biceps and triceps

Brachioradialis

Rectus femoris

Vastus medialis

Gastrocnemius
(calf muscle)

Trapezius

Latissimus dorsi

Gluteus maximus

Body, Front View

The human body is quite complex, but you can represent parts in less detail, and let the viewer's knowledge of what should be there fill in the rest. Start with the front so everything will be symmetrical, the way it was when you learned to draw faces. Remember?

1 Start with the head. It's not necessary to render it fully at this point. Bring the neck down to the shoulders. As a guide, it is useful to sketch a line across the shoulders where the right and left clavicle would be. This gives you a sense of direction for the rib cage; draw that next.

2 Place a small circle at the end of each shoulder. These will approximate the shape of the deltoid muscles. Next, lightly draw the spine as a straight line running down from the ribs. At the end, sketch in the hip area as a circle.

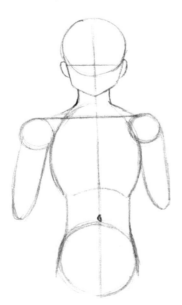

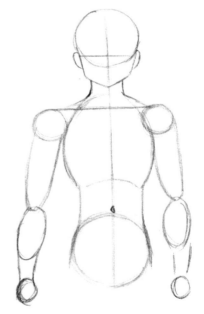

3 Connect the ribs and the hips. Notice the navel is close to the narrowest part of the waist. Begin the upper arms with two sausage shapes. The elbows will end about waist level.

4 When drawing the forearm, allow the upper part to bulge a bit. It may be helpful to sketch in a small oval for this purpose. Also add a small oval at the end of the arm to begin the hand.

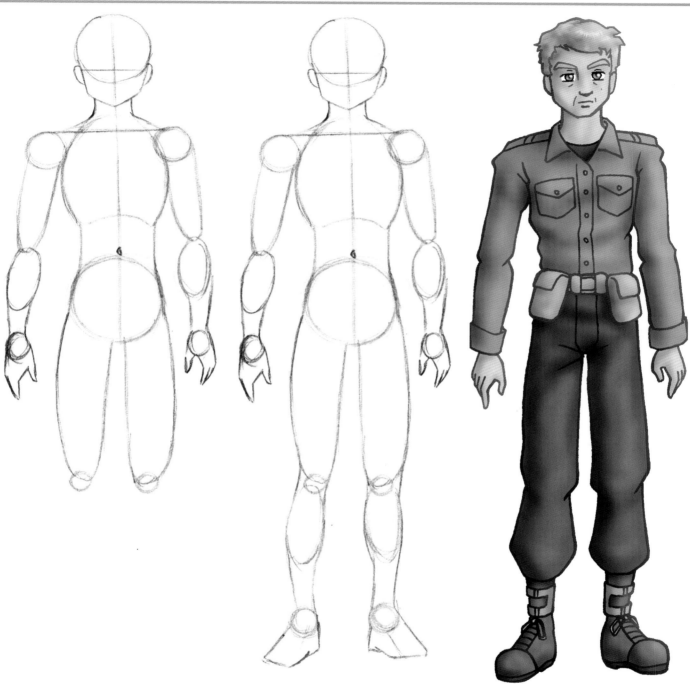

5 Define the hand a bit more by starting with a mitten shape. Next work in the thighs as two large sausage shapes. The small circles at the ends are, of course, the kneecaps, and they will give you an idea of where the knees will bend.

6 Extend the lower legs just as you did the arms. If it helped making those small ovals before, use them again to show the calf muscles. Two small circles at the ends of the legs give shape to the ankles. Use them as a guide when pivoting the feet, which you'll add last.

Body, Three-Quarter View

Drawing in three-quarter view lets the viewer interpret both the front and the side. Usually when you look at someone, you don't see him or her directly from the front or directly from the side, so the three-quarter view gives the viewer a better sense that the subject is in real space. In other words, it is more natural.

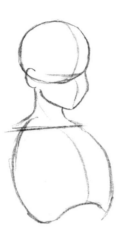

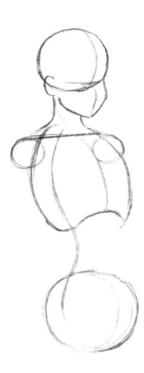

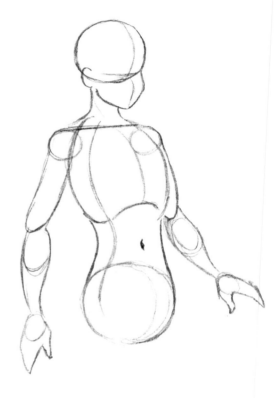

1 Draw the head, and slope the neck down into the shoulders. To better visualize how the rib cage sits, as before, sketch a line across where the clavicle will be. Add the rib cage, making sure it is tilted slightly backward.

2 Lightly draw the spine for reference. See how it curves around the back of the rib cage, turns in at the waist and makes a final curve around the back of the hips? While we're at it, sketch in the hip area as a circle. If you're making a female body, wider hips are better.

3 Connect the hips and rib cage, and then add the arms.

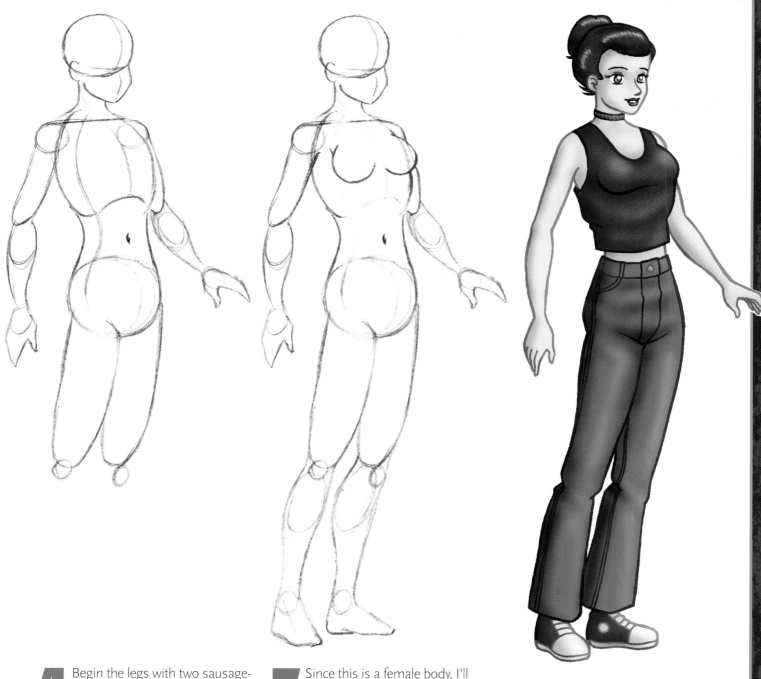

4 Begin the legs with two sausage-shaped thighs. Don't forget to use the kneecaps to define the lower halves of the legs.

5 Since this is a female body, I'll give you a word on drawing breasts. Keep in mind that breasts are not part of the musculature. They are lumps of tissue that actually sit over top of the pectoral muscles.

Body, Profile

If you were able to get through drawing faces in profile, the rest of the body should be easy. I almost never draw a figure in direct profile. Usually I turn the body ever so slightly toward or away from the viewer. This results in a more natural-looking pose.

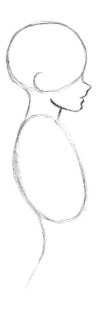 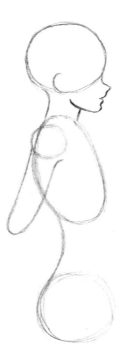 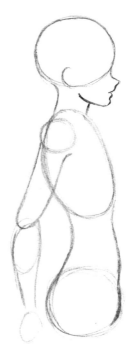

1 Draw a slanted oval rib cage below the neck. Then add a spine that curves in and out again.

2 Draw a circle for the hips at the bottom of the spine, and a smaller circle at the shoulder to start the upper arm.

3 A curved line from ribs to hips forms the stomach. Next, finish the forearm.

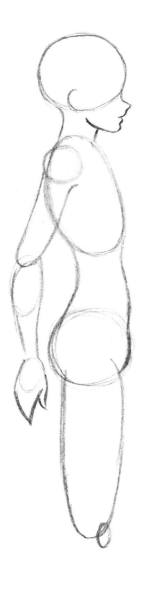

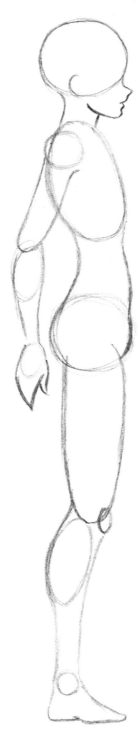

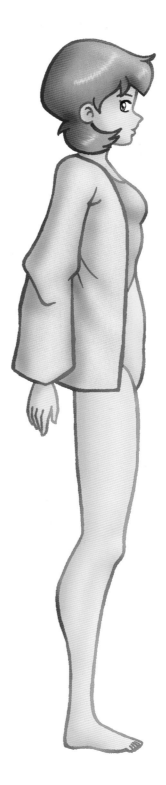

4 Join the thigh to the hip, and add the kneecap. From this view, the knee is a flattened oval rather than a circle.

5 Draw the bottom of the leg, noticing how it curves back from the knee joint.

Body Types

Although most every human body has essentially the same parts, not every person has the same build. The anatomy may be the same, but there are differences in size and proportion across various body types.

CHIBI STYLE

Not all manga characters are drawn with realistic proportions. Another popular style within the manga tradition is the chibi (chee-bee). The word itself means small or cute, and that's how these characters look. A chibi is short with a small body and large head. Simplified details and abnormally large eyes enhance their cuteness.

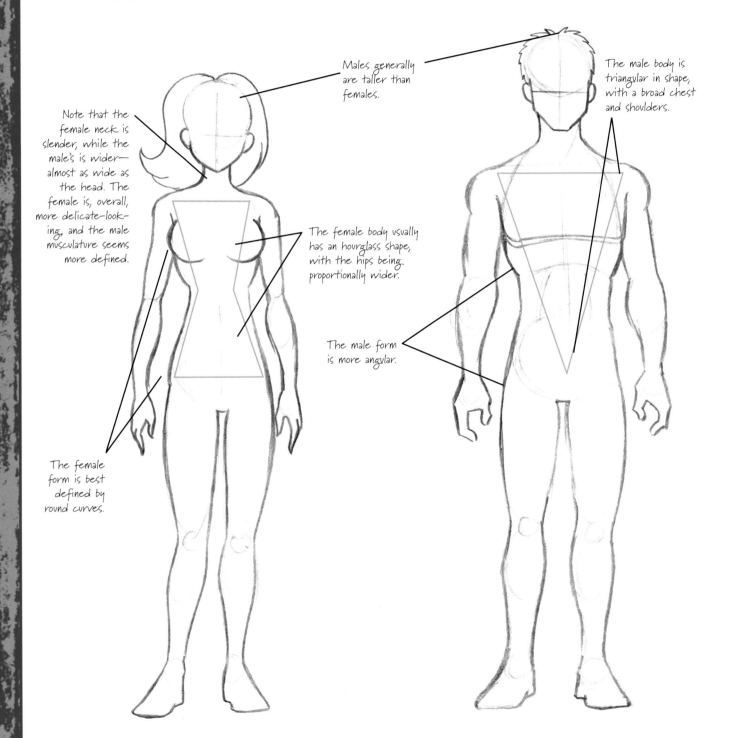

Males generally are taller than females.

Note that the female neck is slender, while the male's is wider—almost as wide as the head. The female is, overall, more delicate-looking, and the male musculature seems more defined.

The female body usually has an hourglass shape, with the hips being proportionally wider.

The female form is best defined by round curves.

The male body is triangular in shape, with a broad chest and shoulders.

The male form is more angular.

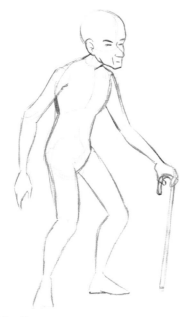 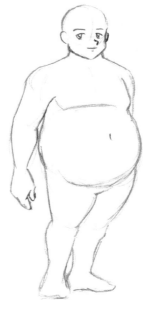

Older Person

An older person may appear shrunken or hunched. Notice that the nose and ears are quite large, since these parts never stop growing through one's lifetime.

Children

Young children have much larger heads in proportion to their bodies. The younger the child is, the greater the difference.

Big Guys

Adding poundage to a figure may be as easy as creating stockier limbs and a round gut.

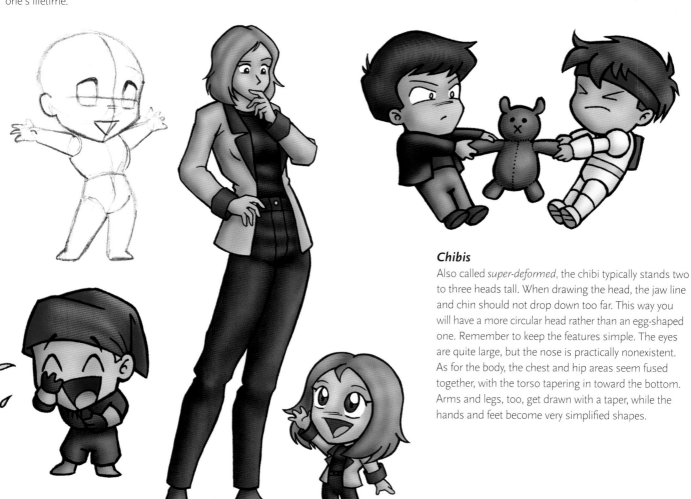

Chibis

Also called *super-deformed*, the chibi typically stands two to three heads tall. When drawing the head, the jaw line and chin should not drop down too far. This way you will have a more circular head rather than an egg-shaped one. Remember to keep the features simple. The eyes are quite large, but the nose is practically nonexistent. As for the body, the chest and hip areas seem fused together, with the torso tapering in toward the bottom. Arms and legs, too, get drawn with a taper, while the hands and feet become very simplified shapes.

Hands

You can draw hands in countless positions and angles. Practice drawing a basic hand, and then try to find some illustrated examples of other hand positions. If you can't find an example of a specific position, have someone hand model for you, or use your own.

1 Draw a small circle at the end of the arm.

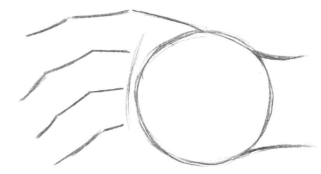

2 Sketch in the segments of the four fingers as simple lines. Depending on the positions of the fingers and your point of view, it also can be good to block in the hand as a larger shape like a mitten.

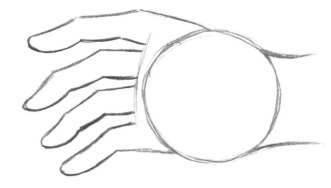

3 When you are happy with the finger configuration, flesh them out.

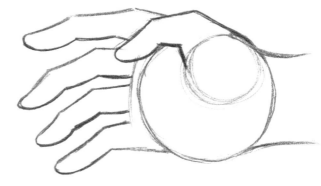

4 Draw a rough circle at the base of the index finger; this serves as the pivoting point for the thumb. Add the thumb just as you added the other fingers.

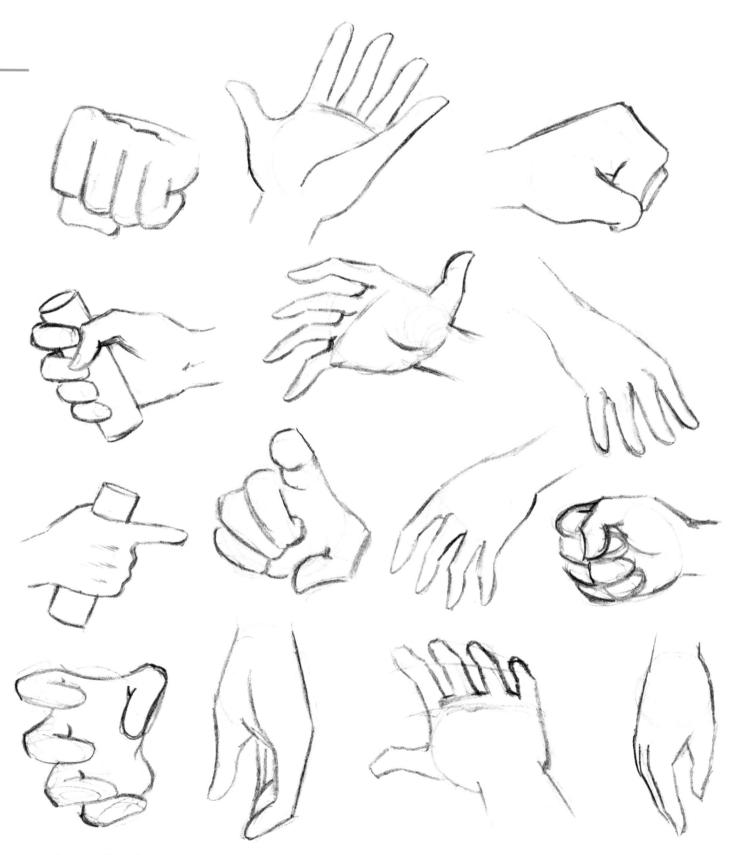

Hands From All Angles

Feet

People have a fear of drawing feet, so they find ways to hide them, like having their subject stand in tall grass. There is really nothing to worry about—just think of feet as simple shapes.

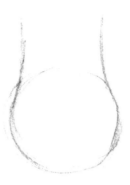

1 Begin with a small circle at the end of the leg. The foot will pivot here at the ankle.

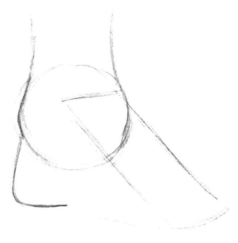

2 Add a rounded *L* shape below the ankle for the heel. In the front, the foot slopes down to the floor. Use a narrow plane as a reference. The wedge shape of the foot should be apparent now.

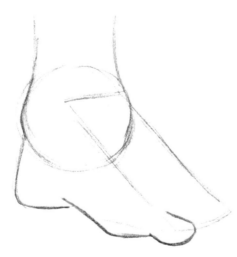

3 In the bottom corner of the rectangular plane, draw the big toe. Next complete the instep between toe and heel.

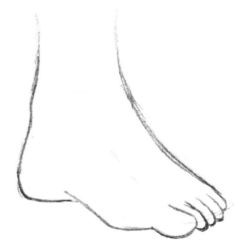

4 Finally, add each of the remaining toes. Notice, from this position, that the toes appear to be curving away. Take care that they do not end up looking all the same length or in a straight line across the front of the foot.

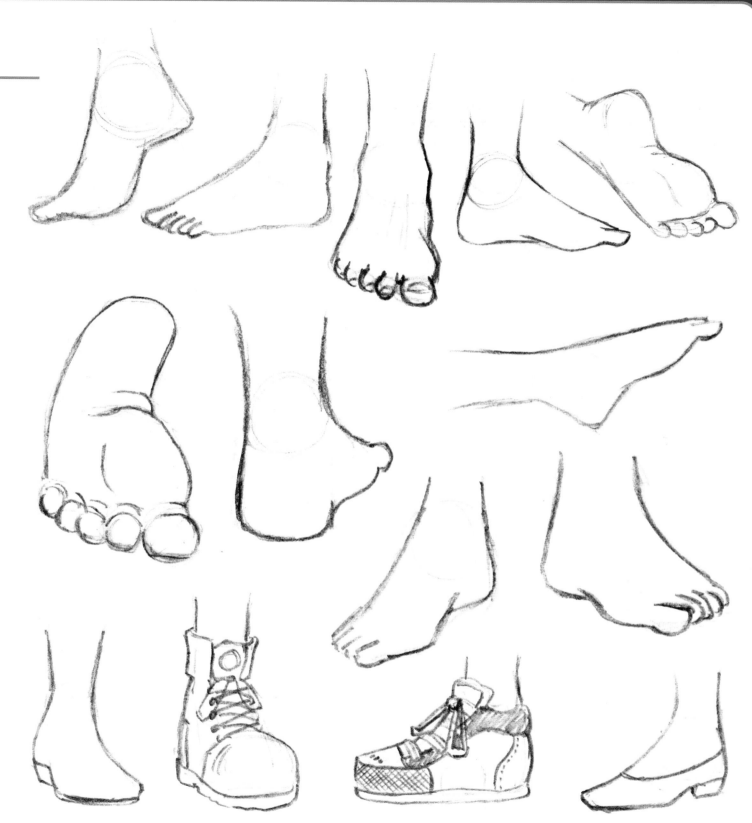

Feet From All Angles

Figures in Perspective

Drawing a single figure in the middle of an empty piece of paper may be fine, but what if you want to show a group of people, and you want to place them in a setting? In this case, it is important to understand something about perspective. Perspective deals with the figure's relative size compared to everything else around it. For instance, if a character is standing in a room, you want him to look as if he will fit through the door behind him.

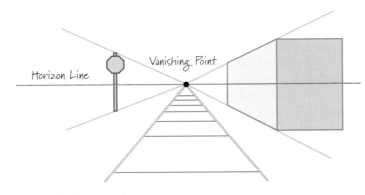

One-Point Perspective

The first type of perspective is called one-point because there is only one vanishing point on the horizon or eye-level line. Lines that meet at this point show how an object's apparent size shrinks as it moves away from the viewer.

PERSPECTIVE TERMS

Horizon Line: *The line where the Earth and the sky meet. It is also your eye-level line.*

Vanishing Point: *The point(s) where all parallel lines meet on the horizon line.*

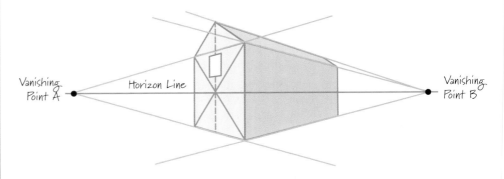

Two-Point Perspective

In two-point perspective there are two vanishing points. One point connects with the length, and the other with the width of an object. The third dimension, the height, is represented by parallel lines that run up and down.

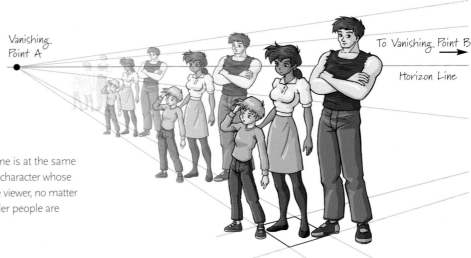

Use the Horizon Line as a Guide

Remember that anything that lies on the horizon line is at the same height as the viewer's eyes. For example, a standing character whose eyes are on the horizon line is the same height as the viewer, no matter how close or how far away they are. The eyes of taller people are above the horizon, and shorter people are below.

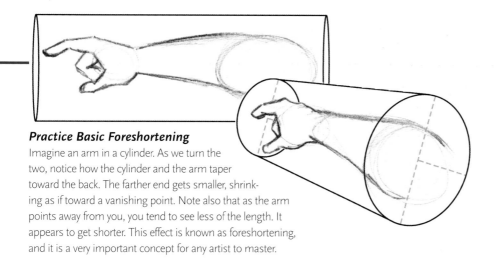

Practice Basic Foreshortening

Imagine an arm in a cylinder. As we turn the two, notice how the cylinder and the arm taper toward the back. The farther end gets smaller, shrinking as if toward a vanishing point. Note also that as the arm points away from you, you tend to see less of the length. It appears to get shorter. This effect is known as foreshortening, and it is a very important concept for any artist to master.

GOOD BOOKS

There are entire books dedicated to teaching perspective. I only touch on the basics here, so if you are a serious art student it is a good idea to pick one of these books up. Check out page 94 for some recommendations.

Running Figure

Looking at this running figure gives you some idea of how foreshortening is used in a drawing. Both the upper arms are foreshortened. The body is leaning forward, so the chest appears flattened. And the free leg is at such an angle that we no longer see the lower half of it. Foreshortening is a powerful tool for creating depth in your drawings, but there are right and wrong ways to use it.

Bad Foreshortening

Consider the first figure here with his finger pointed at the viewer. Because the pointing arm is aimed directly at us, we can hardly see any of its length. While this may be technically correct, it is visually poor. This view makes it extremely difficult to even identify that as his arm.

Good Foreshortening

Now the arm is pointing slightly off to the side and down. This lets us see enough of the length to read it as an arm, but still gives the impression that he is pointing at us.

Drawing Dynamic Figures

Creating figures that seem to move through space will bring far more interest to your drawings. The human body can bend and stretch itself into many different positions, so there can be no step-by-step method to cover them all. Your best bet is to study how the body moves by observing actual people. Make quick sketches of anyone performing some task or sitting in some position. While doing so, keep in mind what you know about the anatomy of the body. Here are some examples for you.

CONTRAPPOSTO HISTORY

The contrapposto pose originated in the classical Greek period, and carried over to the Renaissance. Perhaps the most famous example of this is Michelangelo's David.

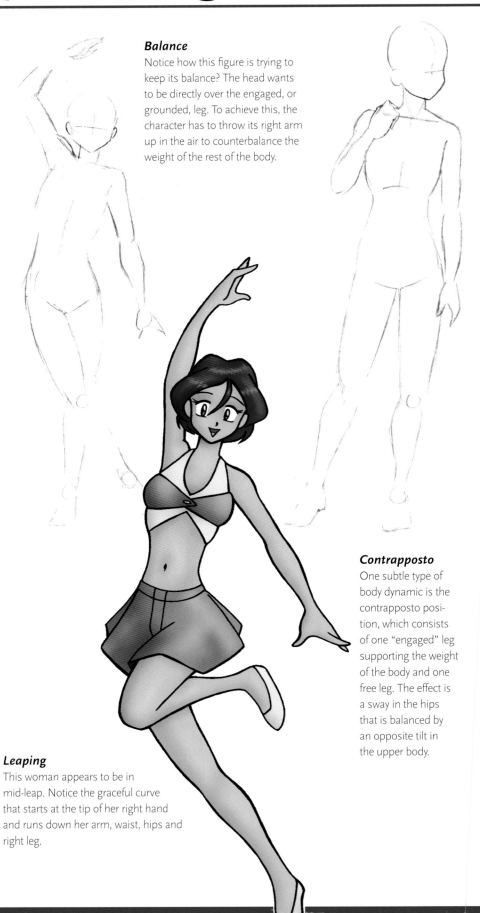

Balance
Notice how this figure is trying to keep its balance? The head wants to be directly over the engaged, or grounded, leg. To achieve this, the character has to throw its right arm up in the air to counterbalance the weight of the rest of the body.

Contrapposto
One subtle type of body dynamic is the contrapposto position, which consists of one "engaged" leg supporting the weight of the body and one free leg. The effect is a sway in the hips that is balanced by an opposite tilt in the upper body.

Leaping
This woman appears to be in mid-leap. Notice the graceful curve that starts at the tip of her right hand and runs down her arm, waist, hips and right leg.

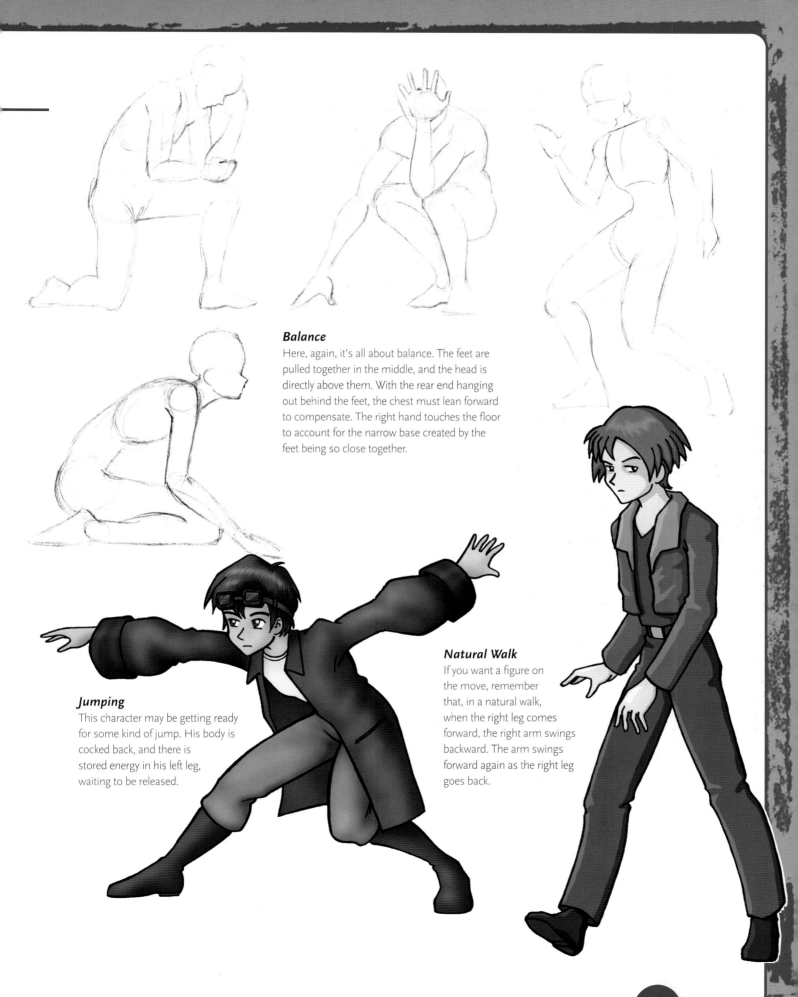

Balance

Here, again, it's all about balance. The feet are pulled together in the middle, and the head is directly above them. With the rear end hanging out behind the feet, the chest must lean forward to compensate. The right hand touches the floor to account for the narrow base created by the feet being so close together.

Jumping

This character may be getting ready for some kind of jump. His body is cocked back, and there is stored energy in his left leg, waiting to be released.

Natural Walk

If you want a figure on the move, remember that, in a natural walk, when the right leg comes forward, the right arm swings backward. The arm swings forward again as the right leg goes back.

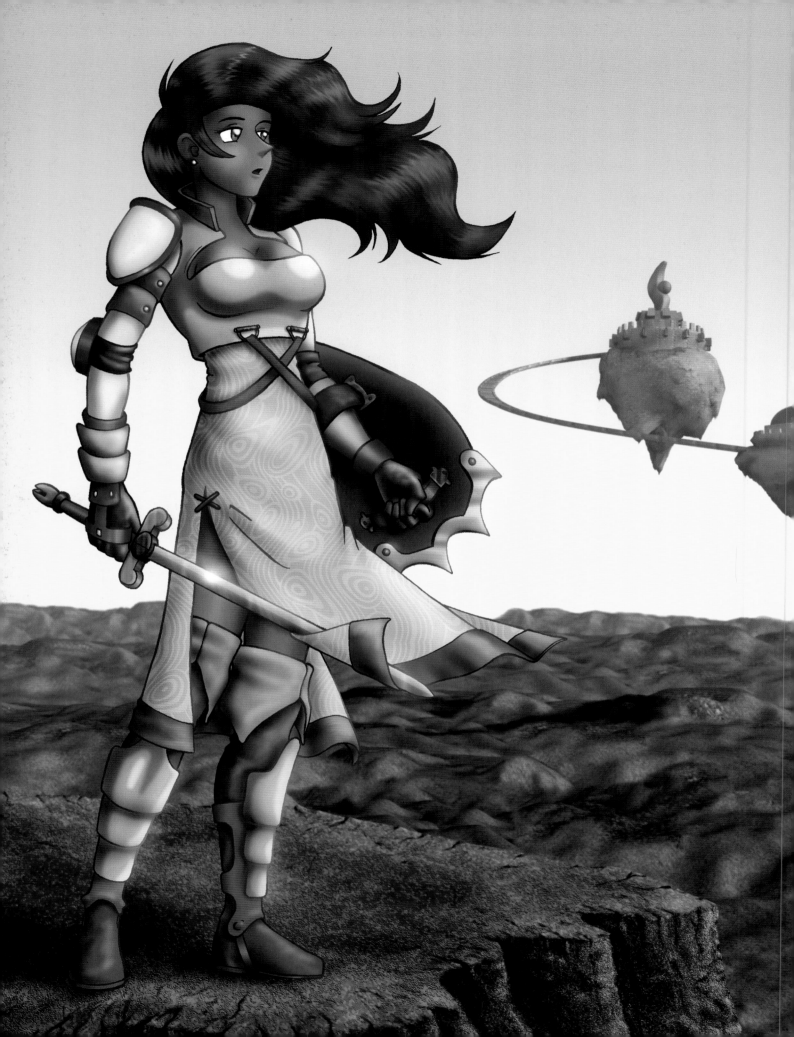

3 CLOTHES AND PROPS

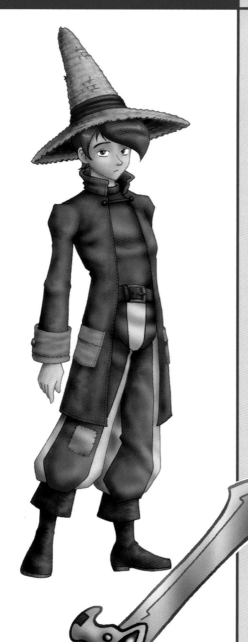

What a character wears and carries says a lot about him, and, like hairstyle, the sky is the limit. Get inspired from the folks you see on the street or draw completely from the wildest depths of your imagination. In this chapter, you'll discover the details that help make a character unique. First you'll learn the tips and tricks of construction, and then I'll show you how to pull different outfits and accessories together to create specific character types.

Drawing a T-Shirt

All the different types of shirts that exist would fill another book, so let's look at one of the most basic forms, the T-shirt. Spread flat on the floor, the T-shirt, with its armlets stretched outward, resembles a letter *T*, hence the name. Now few people go around walking with their arms stretched out. It makes doors a problem. So let's see what happens when we stuff a body up in there.

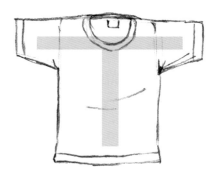

Basic T-Shirt

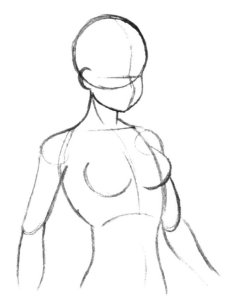

1 Keep in mind that the body on the page represents a solid 3-D form, and that clothing drapes over and around that form, conforming to its shape.

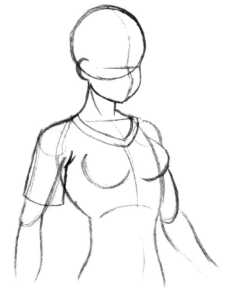

2 The collar of a T-shirt is a good example of this conformity. Drape it around the shoulders much as you would a necklace. Make the sleeve a flexible tube that hangs down around the arm.

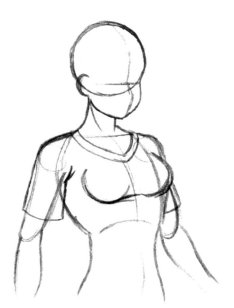

3 Usually, when fabric bends it buckles. You can show this in your drawing with lines leading away from the bend. Notice the buckling here at the armpit and across the chest.

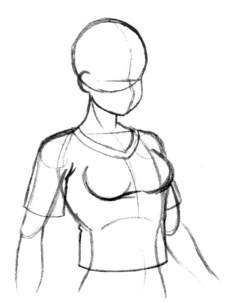

4 When drawing any loose-fitting clothing, consider how gravity affects it.

Jeans

As with most other clothing, a pair of jeans can be drawn using the same guidelines. Here, you can see the material buckling at the crotch and knees. Study many types of clothing, and pay close attention to details like stitching and folds.

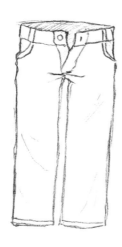

Basic Jeans

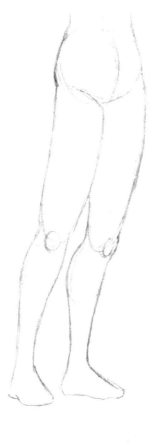

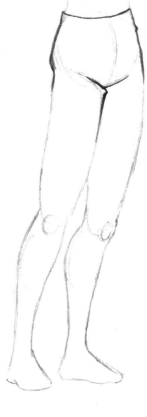

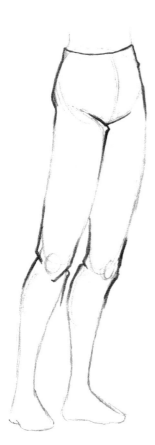

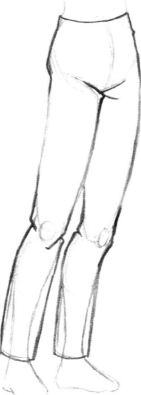

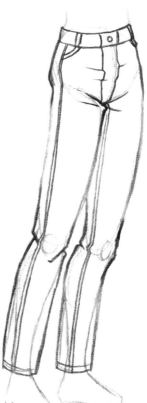

Clothing Gallery

Take a look at these examples, and notice how the form of the body is apparent even under layers of material.

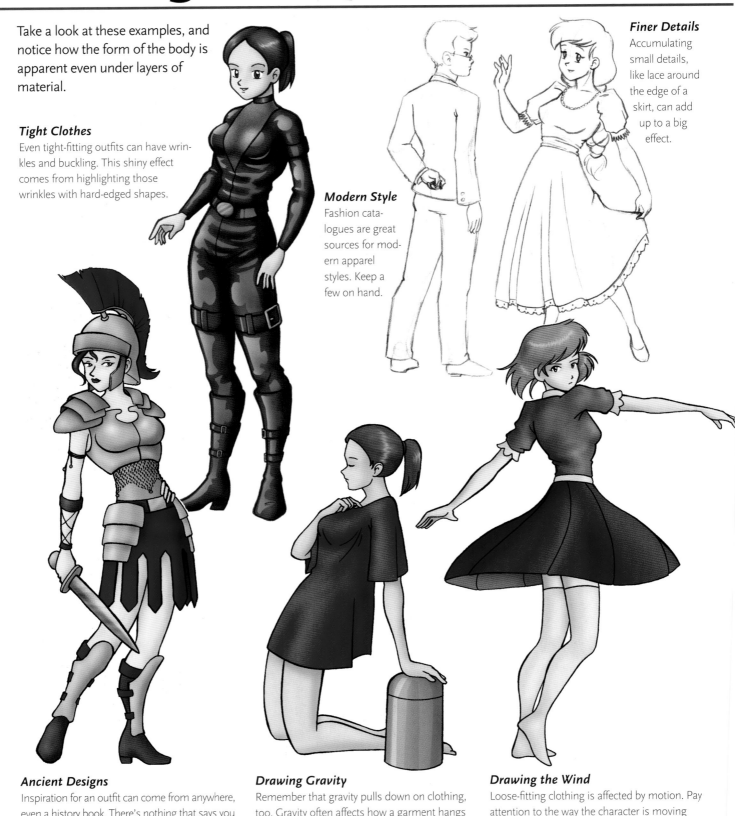

Tight Clothes
Even tight-fitting outfits can have wrinkles and buckling. This shiny effect comes from highlighting those wrinkles with hard-edged shapes.

Modern Style
Fashion catalogues are great sources for modern apparel styles. Keep a few on hand.

Finer Details
Accumulating small details, like lace around the edge of a skirt, can add up to a big effect.

Ancient Designs
Inspiration for an outfit can come from anywhere, even a history book. There's nothing that says you can't alter an ancient design to fit your own needs.

Drawing Gravity
Remember that gravity pulls down on clothing, too. Gravity often affects how a garment hangs and folds.

Drawing the Wind
Loose-fitting clothing is affected by motion. Pay attention to the way the character is moving and the direction of the wind.

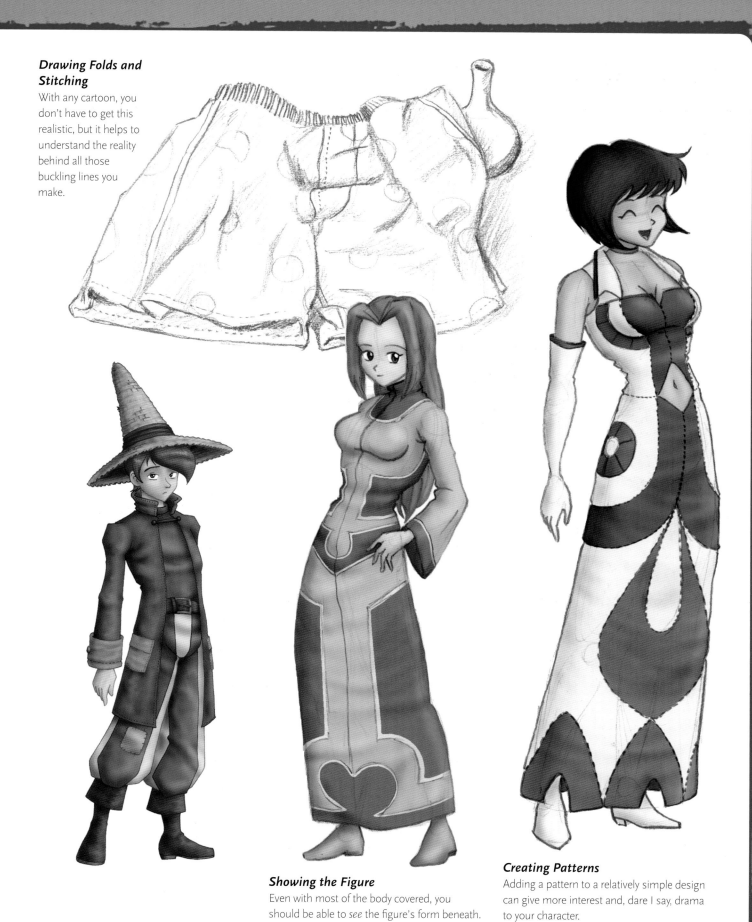

Drawing Folds and Stitching

With any cartoon, you don't have to get this realistic, but it helps to understand the reality behind all those buckling lines you make.

Showing the Figure

Even with most of the body covered, you should be able to *see* the figure's form beneath. Always sketch the full figure before drawing clothing.

Creating Patterns

Adding a pattern to a relatively simple design can give more interest and, dare I say, drama to your character.

Designing Weapons and Props

A prop is any item that a character handles or uses. By this definition, a weapon is just a type of prop. Here are some examples of weapons and other objects. Pay close attention to the construction methods involved, just as you did with drawing figures.

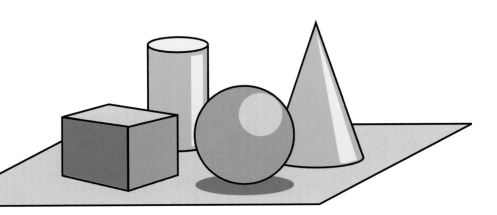

Study the Simple Shapes
The first thing to consider when drawing any object is how to break it down into simple shapes. A drinking glass may be as easy as a cylinder, but more complex items might require a combination of several basic forms. Let's examine some now.

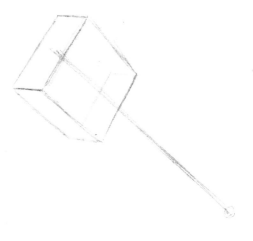

Designing the Staff
Create the curved shape of the head inside the box. Add extra details such as the spikes lining the top.

Basic Staff Shape
To begin this staff, start with a box to represent the head of the staff. Then sketch a rough line to show its length.

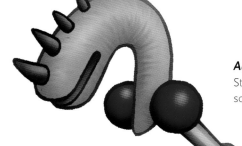

Adding the Details
Staves come in a wide variety of styles, so be creative!

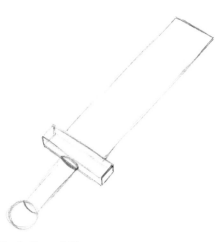

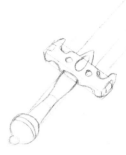

Basic Sword Shape

At the heart of this sword, you will find a number of simple shapes. The most important are the plane on which the blade lies, the box shape of the hilt and the cylindrical handle.

Designing the Sword

Once these guides are laid out, you can begin the actual form of the sword. Inscribe any kind of blade you like into the plane. Designing a weapon is one occasion where you can set your imagination free.

Adding the Details

Finishing up is just a matter of adding more detail to the shapes you have created. Swords can be encrusted with jewels, engraved with mystic symbols or have leather-wrapped handles.

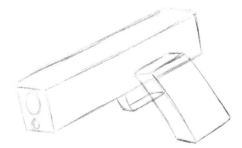

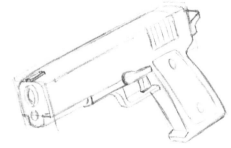

Basic Gun Shape

Firearms come in assorted sizes and shapes, but most consist of a barrel and a handle for gripping. Represent both of these with long boxes.

Designing the Gun

Refine these boxes and meld the two together to achieve this gun's look.

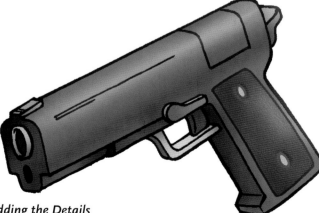

Adding the Details

Although it is useful to draw with a loose, free hand when sketching the general shape, guns often have straight, clean lines. So, it is a good idea to use a straight edge for your finishing line.

YOUR OWN MANGA MORGUE

Start building a morgue. No, this doesn't mean you'll be keeping dead things. An artist's morgue is a collection of reference materials, photos, drawings and articles. If you happen to see a cool-looking car or a fancy dress in a magazine, just clip it out and save it. That way, if you ever want to draw something, but you aren't sure what it should look like, you may have something like it in your morgue.

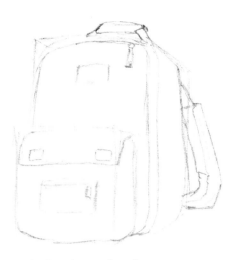

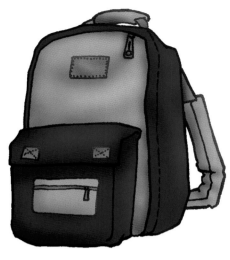

Basic Backpack Shape

Basic construction of this pack is simple enough—just a large rectangular box and a smaller one for the little pouch in front.

Designing the Backpack

Here, we added some flaps and straps.

Adding the Details

The details of this item are very similar to what you would do for clothing. Use folds and stitching to tie it all together.

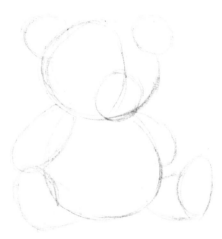

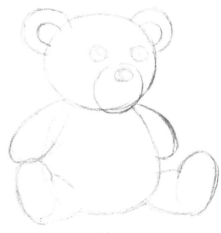

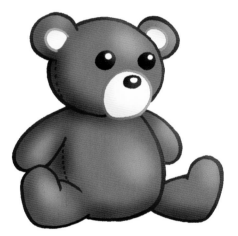

Basic Teddy Bear Shape

As you can see, starting this bear is much like drawing a character. It's mostly circles and sausage shapes.

Designing the Teddy Bear

Simply add a face here, and define the arms and feet more.

Adding the Details

The major difference between a toy bear and a cartoon character is that the toy is full of stuffing. So, remember to add details like seams and button eyes.

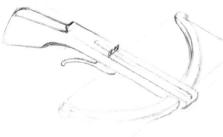

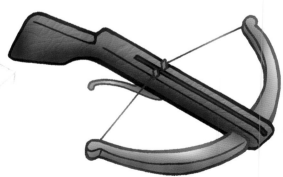

Basic Crossbow Shape

The first sketch may not look much like a crossbow, but by now, you should be getting the idea behind this method of construction.

Designing the Crossbow

Refine the side members of the bow to fit within the confines of the box.

Adding the Details

Adding more details builds the completed picture. Remember a crossbow needs a trigger and a drawstring. Don't be afraid to embellish as with the sword.

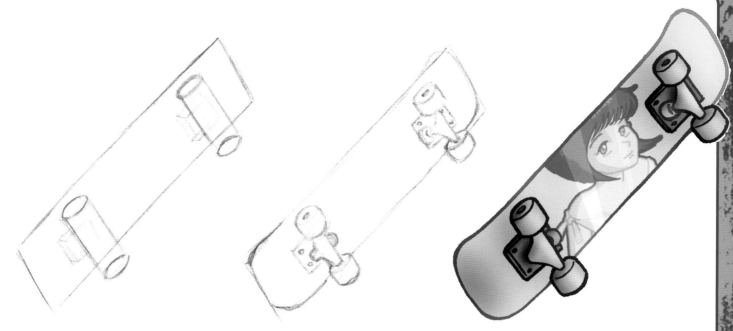

Basic Skateboard Shape

The construction of this skateboard is deceptively simple. Draw the board itself within a narrow plane. Draw a cylinder for reference for each set of wheels.

Designing the Skateboard

Be careful where you locate the wheels and the hardware that goes with them. Draw them evenly spaced so the board looks balanced. Curve up the board on the ends.

Adding the Details

Just for fun, you can decorate the bottom side with—what else—MORE MANGA!

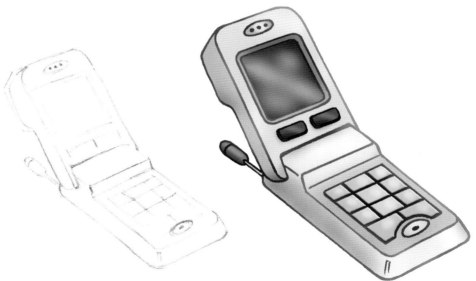

Basic Phone Shape

The basic shape of this phone is two rectangular boxes. Technology has a way of changing rather quickly. This cellular phone might look a bit out-dated by the time you read this, but the basic rules of construction for high-tech equipment should stay more or less the same.

Designing the Phone

For this device, larger boxes just get detailed with smaller boxes and squares. Here, you can also round out the corners.

Adding the Details

Like the gun, mass-produced items often require a straight edge to give your finished lines a clean appearance. Use this when you add the final details.

• SCHOOL GIRL •

Shoujo is a genre of manga directed toward young girls. Many shoujo stories have a young school girl as the main character. Examine some of the features present in the two examples shown here.

STATS

EYES		Large, wide eyes give her a look of excitement and display the exuberance of youth.
HAIR		Straight and bobbed; hair adds some seriousness to her personality, suggesting she might be a little more studious than some of her friends.
BODY		This girl has skinny arms and legs, a slightly larger head and just a hint of an hourglass shape to her figure. Due to her young age, a school girl may not be fully developed. Try to create a blend of features from a young child and a grown woman.
FASHION		Of course, no school girl would be complete without a school uniform. The one pictured here is typical of those worn in Japan, but you might try a more modern outfit with a blazer.

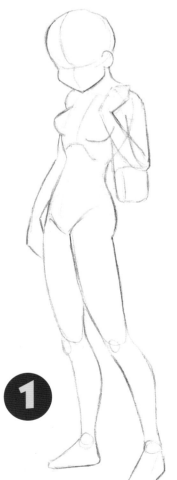

1

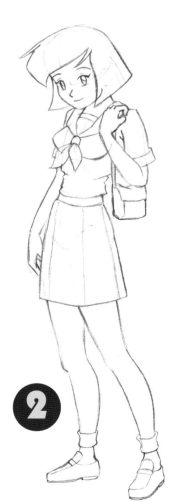

2

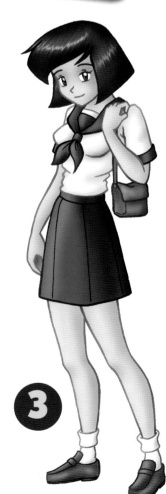

3

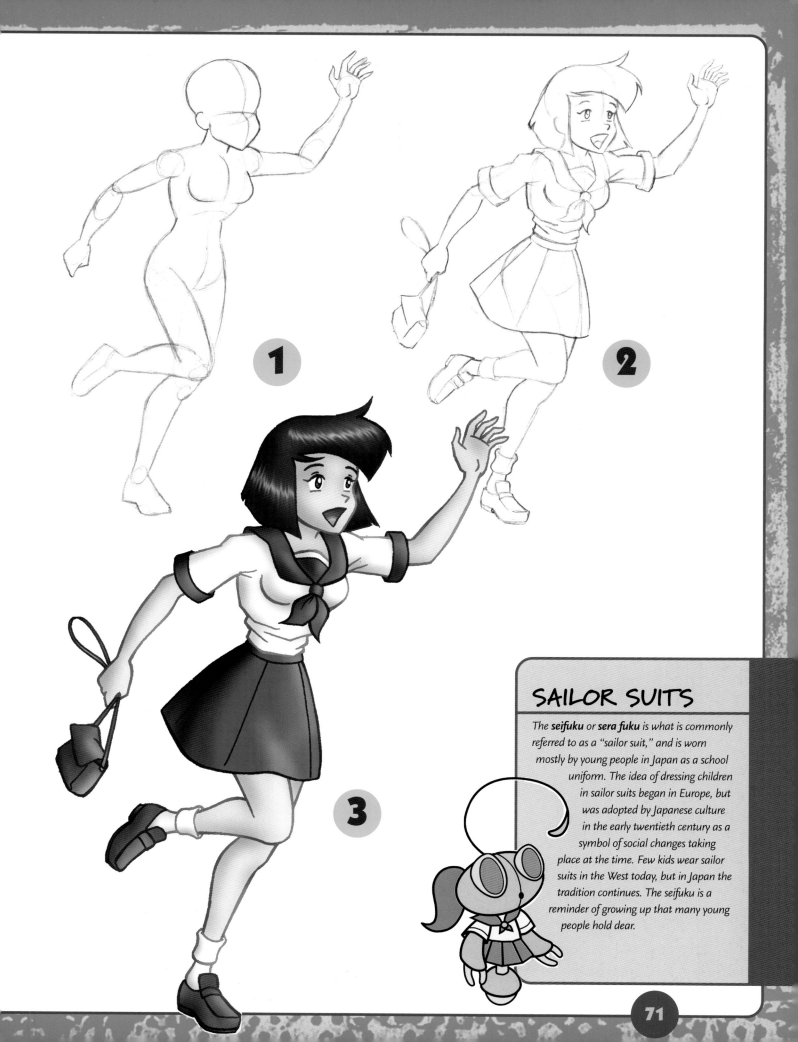

1

2

3

SAILOR SUITS

The **seifuku** or **sera fuku** is what is commonly referred to as a "sailor suit," and is worn mostly by young people in Japan as a school uniform. The idea of dressing children in sailor suits began in Europe, but was adopted by Japanese culture in the early twentieth century as a symbol of social changes taking place at the time. Few kids wear sailor suits in the West today, but in Japan the tradition continues. The seifuku is a reminder of growing up that many young people hold dear.

Beach Bunny

• BEACH BUNNY •

Many a tale have been spun about the beautiful girl whom everyone loves. In Japanese, these girls are called **bishoujo**. One type of bishoujo, the beach bunny, spends her days on warm coastal sands.

STATS

HAIR Long red hair makes her seem wild and untamed.

BODY More mature than the school girl, she has curvier legs and a well-defined hourglass body. She is likely athletically toned from all the surfing and volleyball she enjoys.

FASHION

Swimsuits come in a variety of styles. Most are formfitting, which means you'll really need to hone your figure-drawing skills for this one. A prop, such as a beach ball, shows her playful side.

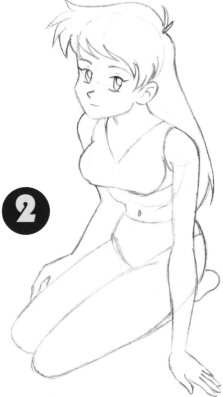

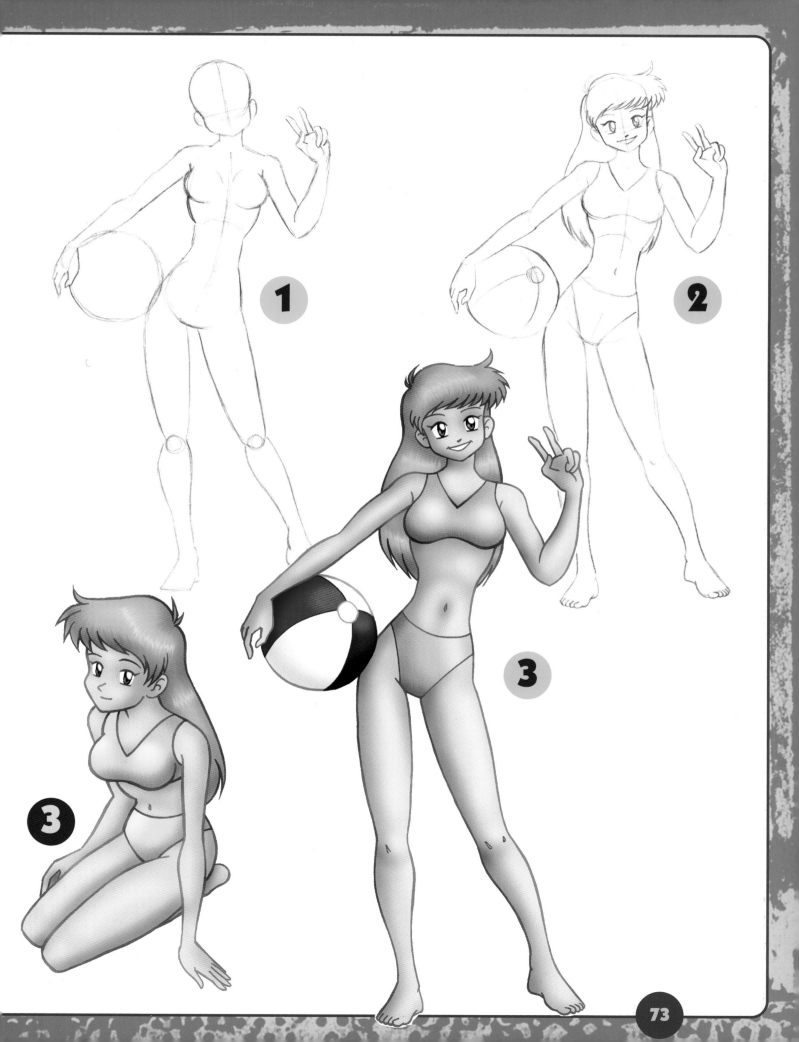

1

2

3

3

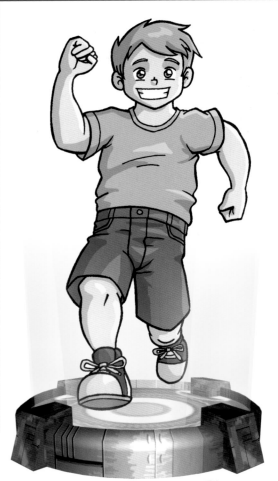

• NICE BOY •

Manga for young boys, or **shounen**, is very popular with children as well as some adults. The shounen often represents a nice boy, positive in nature, who continually tries to better himself. His adventures are a metaphor for growing up and finding a positive place in society.

STATS

EYES Large eyes give away his relative innocence.

HAIR His unkempt hair shows he is still only a kid.

BODY An upright posture and determined grin express his growing self-confidence.

FASHION

Big, clunky sneakers give a feeling of awkwardness.

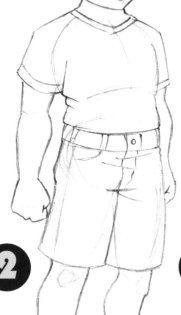

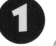

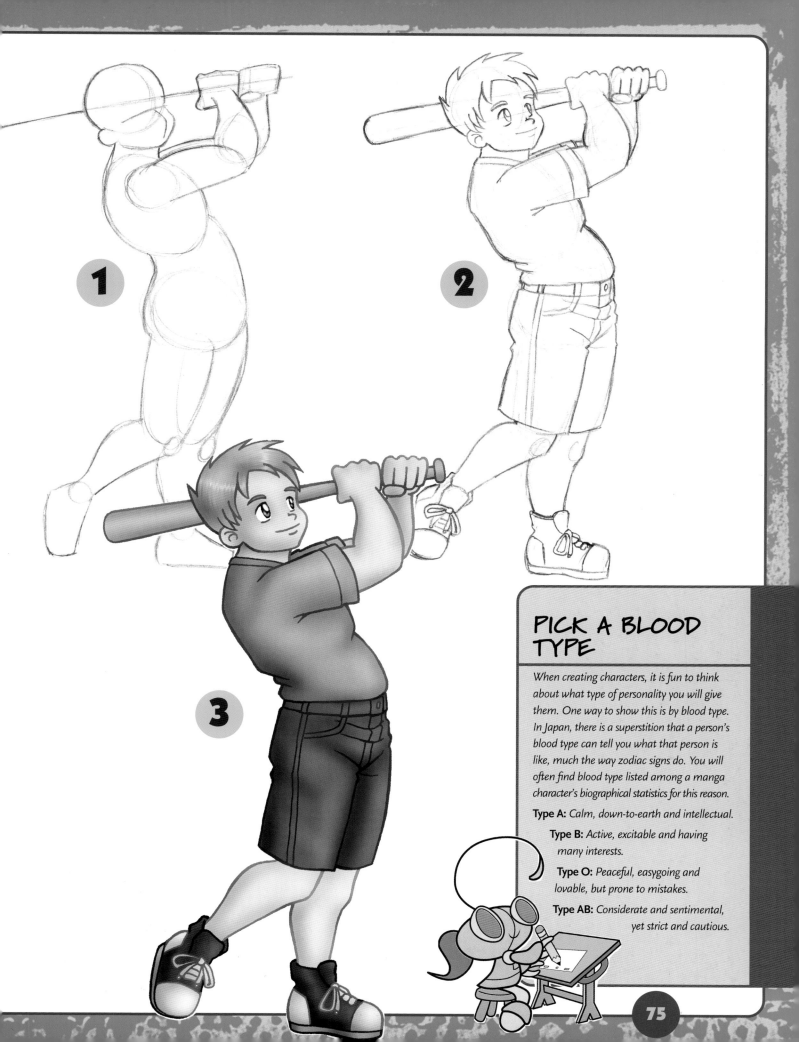

1

2

3

PICK A BLOOD TYPE

When creating characters, it is fun to think about what type of personality you will give them. One way to show this is by blood type. In Japan, there is a superstition that a person's blood type can tell you what that person is like, much the way zodiac signs do. You will often find blood type listed among a manga character's biographical statistics for this reason.

Type A: *Calm, down-to-earth and intellectual.*

Type B: *Active, excitable and having many interests.*

Type O: *Peaceful, easygoing and lovable, but prone to mistakes.*

Type AB: *Considerate and sentimental, yet strict and cautious.*

Bad Boy

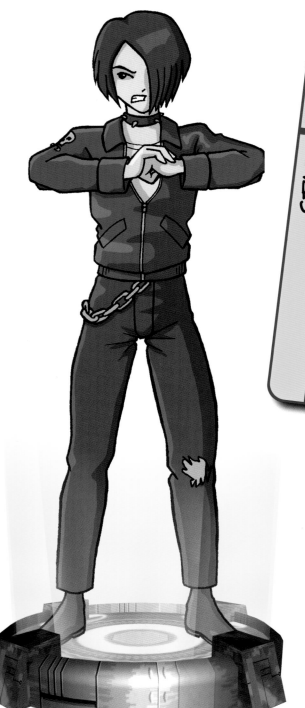

• BAD BOY •

He's unsocial, wild and cool. He's a plain old bad boy! His rugged good looks and air of mystery make him strangely appealing, especially to women. In Japan, they are called **bishounen**, or handsome young men. The bad boy often stands out as one of the most favored characters in any story.

STATS

EYES		Narrow, unexpressive eyes make him seem cold or distant.
HAIR		Long hair that conceals the face suggests he may wish to hide something, perhaps his true feelings.
FASHION		
		A leather jacket, spiked collar and metal chain say he is dangerous and unapproachable.
PROPS		
		This bad boy rides an equally "bad" motorcycle. Don't let the complexity of such things scare you. As with any object, you should break down the motorcycle into simpler shapes, and build upon those until you have the detail you desire. Remember, it will be a big help if you can find an example to use as a model.

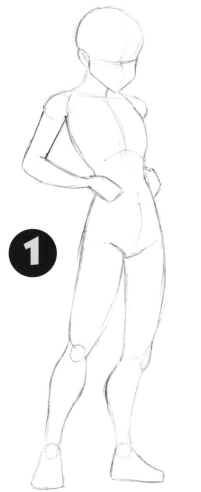

1

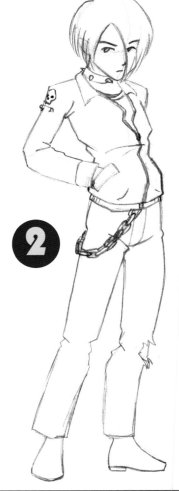

2

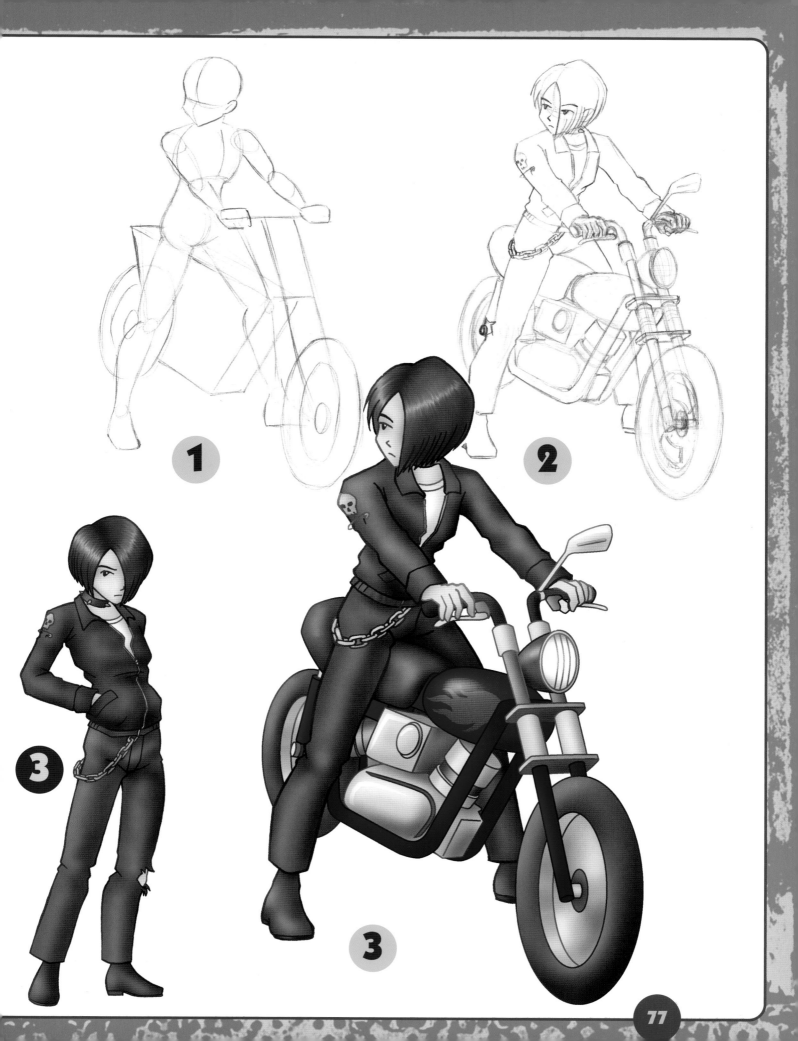

1

2

3

3

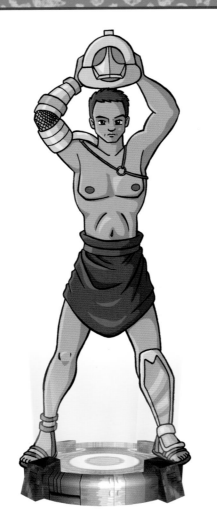

• ROMAN GLADIATOR •

In ancient times, special warriors trained long and hard for sporting combats that entertained the bloodthirsty masses. The Romans outfitted their gladiators to mimic the fighting styles of the peoples they had conquered, so many different types of fighters existed. Some were small and quick, while others were large and powerful—like our friend here.

STATS

HEAD/FACE Before drawing the helmet, lightly sketch the whole head and face. You want to make sure everything lines up right and that there is enough room for features like the nose.

BODY Full of manliness, this big boy has a broad chest and thick, powerful limbs. He works out, so make his pectoral and abdominal muscles well-defined.

FASHION Pay attention to the folds of his loincloth. See how the material buckles and drapes down over the thighs? Shade the shiny metal parts from light to dark. Next, add solid highlighted spots near the lighter edges. This shows how the light source is being reflected toward the viewer. Opposite that, create solid dark shapes to give the impression that a distorted image of the surroundings is also being reflected.

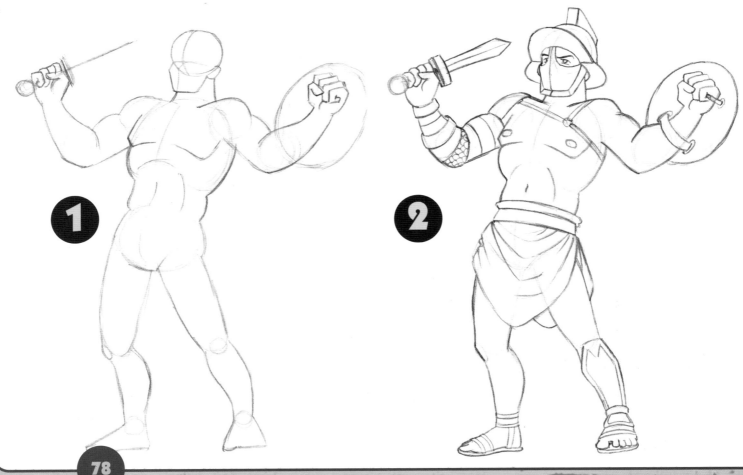

1
2

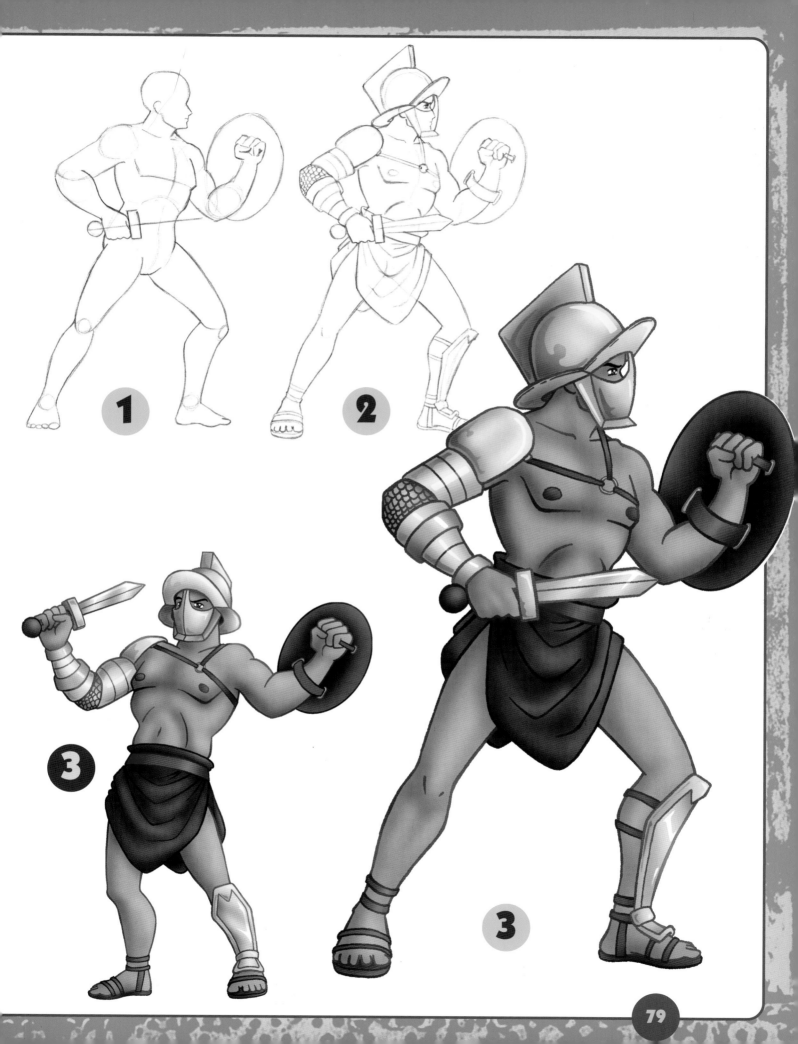

1

2

3

3

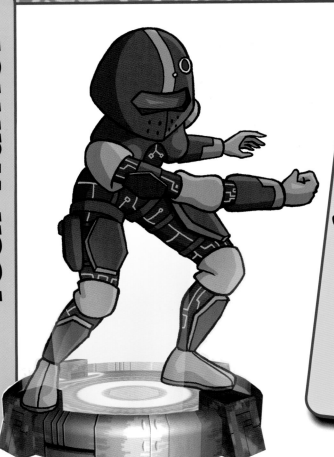

• TECH WARRIOR •

Advanced technologies play an ever-increasing role in modern warfare. Nowhere is this more apparent than in the world of video games. Many games today adopt a manga/anime art style because hi-tech is a manga/anime specialty. Here you can learn how to start with a bare figure and then build upon it.

STATS

EYES Position the eye shielding so the character's eyes can see through it.

FACE There is a human head inside the helmet. It's a good idea to sketch in a face for reference.

FASHION One by one, add all the elements that make up this suit, then fill in the spaces with circuit lines until you cover the entire body in detail.

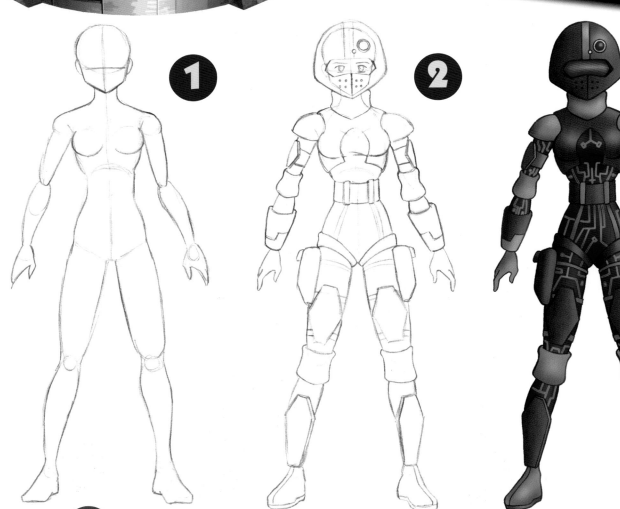

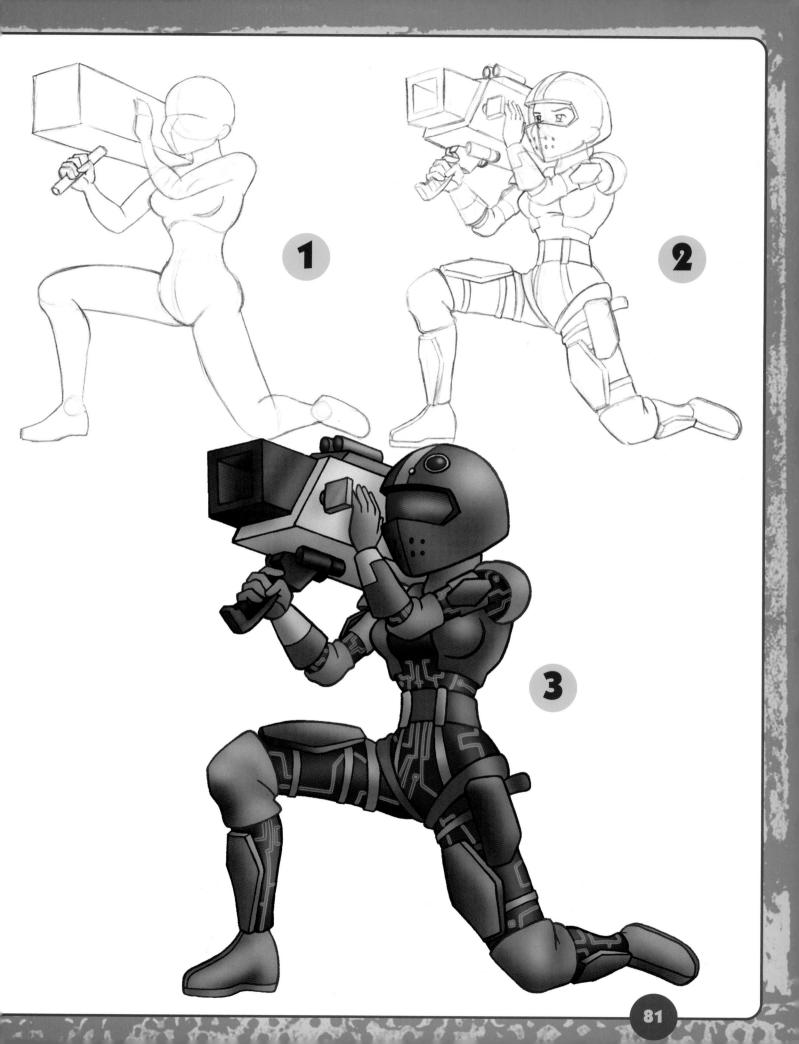

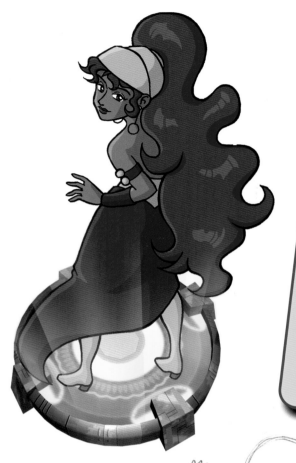

•SORCERESS•

Magical people also appear often in manga, and the feats they perform vary quite broadly. For this reason, the look and style of a sorceress can go in any direction. For instance, a sorceress specializing in fire magic might have a flaming red dress, and a sorceress of the dark arts could have jet-black hair and wear a pair of skulls on her shoulders.

STATS

HAIR She has unusually long, wavy hair, possibly the source of her powers.

BODY If the hair covers parts of her body, as it would from behind, be sure to sketch the hidden parts as well to ensure a convincing pose. The same goes for her legs, which remain mostly underneath the skirt.

FASHION
Our magic user here seems fairly neutral. Almost gypsylike, she wears a long, flowing skirt with a bright pattern, and she is adorned with jewelry.

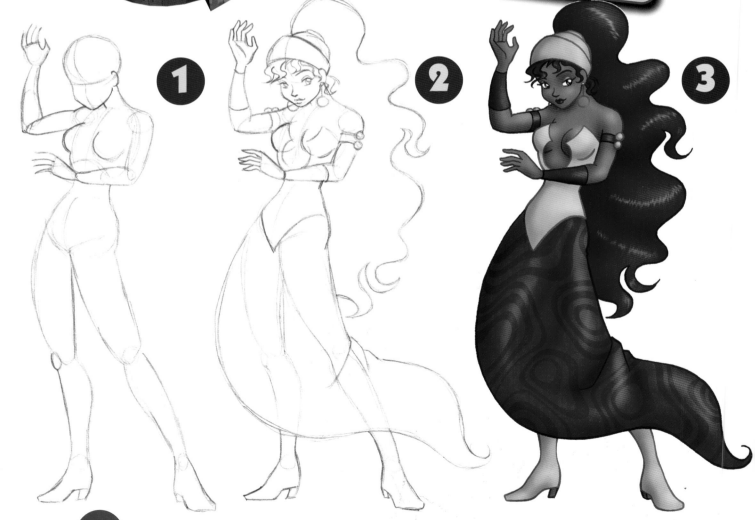

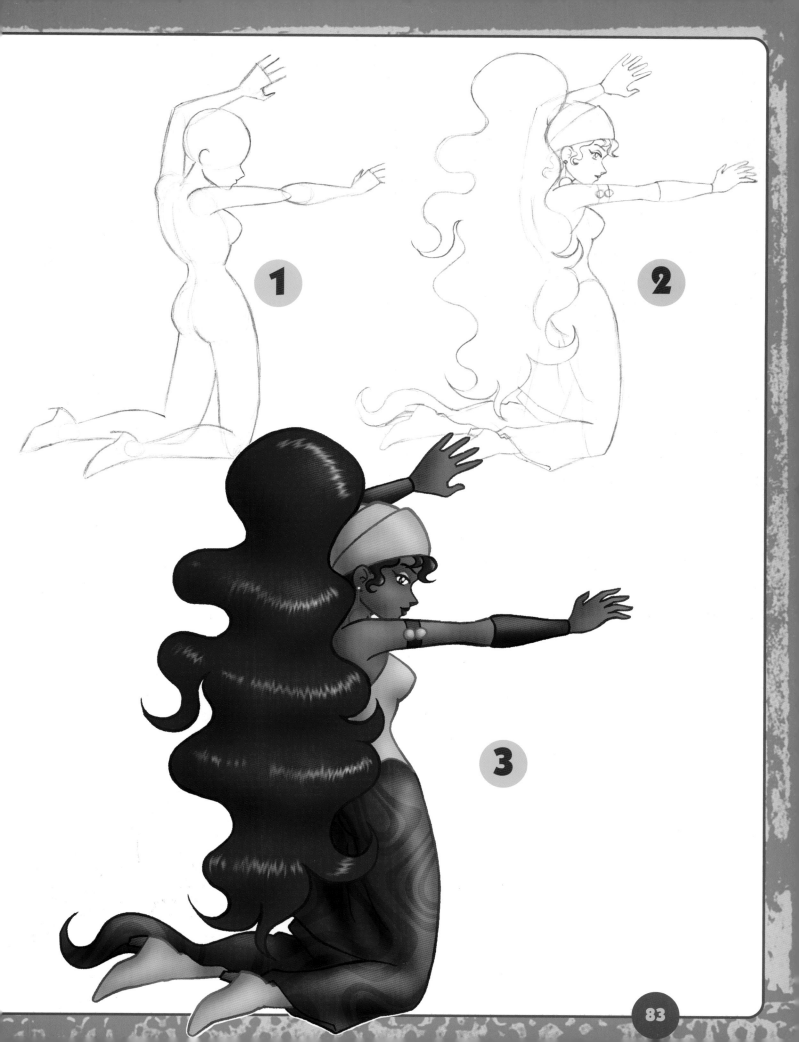

Space Samurai

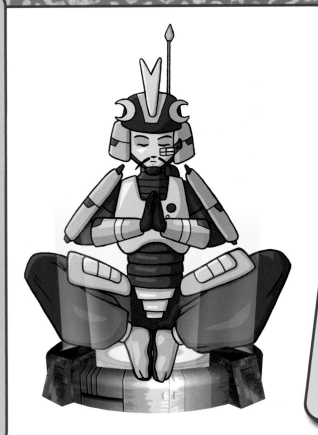

In keeping with Japanese heritage, many manga stories involve samurai, and, as you know, manga also deals with futuristic technology. So why not combine the two? A large part of being creative involves seeing connections between things that at first glance do not appear connected. In this case, a legendary warrior of the past is connected with hi-tech equipment and materials.

STATS

HELMET

The helmet of a samurai has a distinctive shape, so keeping the form similar while changing the materials makes it clear this is a samurai, but no ordinary one.

WEAPONRY

How would a samurai of the past create armor and weapons if he had access to technology of the future? The sword is the "soul of the samurai," so it is doubtful it would be replaced with a ray gun. Instead, the blade might be enhanced with some sort of energy force that causes it to glow.

1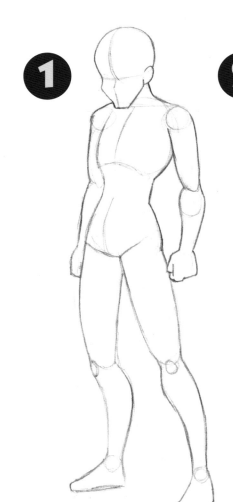

2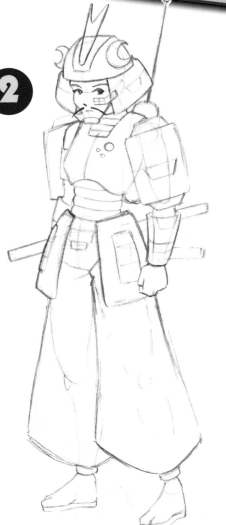

3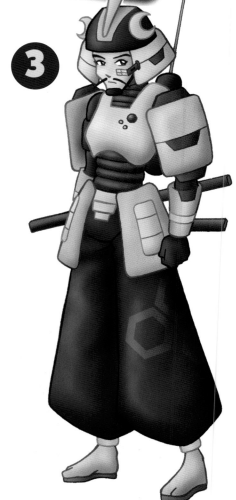

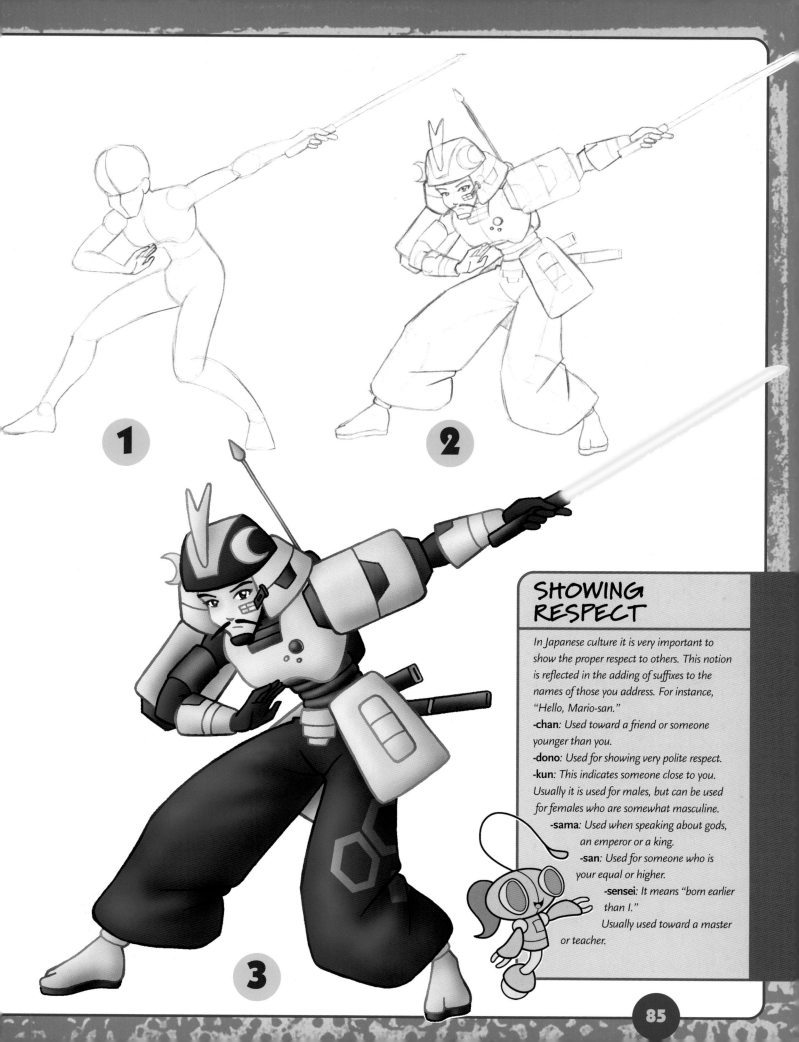

1

2

3

SHOWING RESPECT

In Japanese culture it is very important to show the proper respect to others. This notion is reflected in the adding of suffixes to the names of those you address. For instance, "Hello, Mario-san."

-chan: Used toward a friend or someone younger than you.

-dono: Used for showing very polite respect.

-kun: This indicates someone close to you. Usually it is used for males, but can be used for females who are somewhat masculine.

-sama: Used when speaking about gods, an emperor or a king.

-san: Used for someone who is your equal or higher.

-sensei: It means "born earlier than I."

Usually used toward a master or teacher.

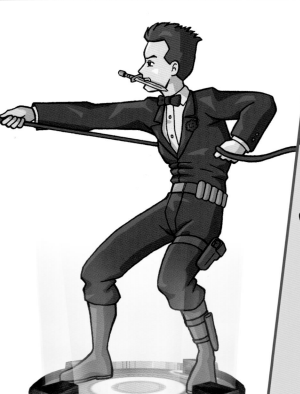

• SPY •

As any good agent will tell you, a spy must be physically fit, have good aim and be dressed to kill. This male spy has suave sophistication with just a touch of the "bad boy," making him a type of bishounen.

STATS

EYES *His narrow eyes give him a look of concentration.*

BODY *He has broad, shoulders and chiseled features.*

FASHION

Combine the tuxedoed spy of intrigue with the military recon spy.

PROPS

Outfit him with a small concealable pistol, and a field knife for the silent kill, and let's not forget a carnation for his lapel.

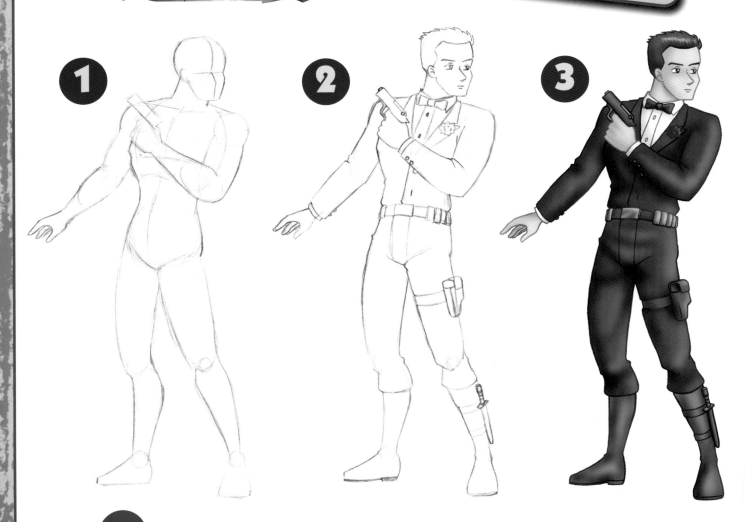

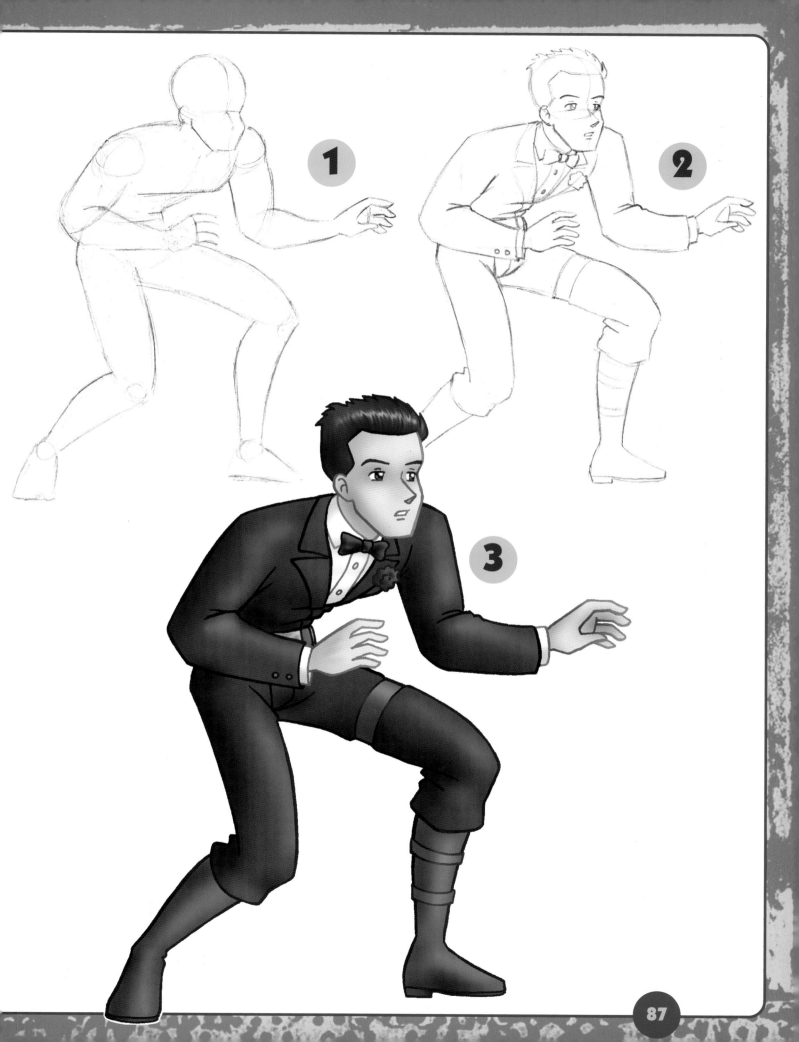

• NEKO •

Anthropomorphism means giving human characteristics to inanimate objects and animals. This, of course, leaves open a wide range of possibilities. We have been talking about the creative combination of seemingly unrelated things. This character could not be a better example of that idea.

One common anthropomorphic character merges a human being with an almost catlike creature. In fact, the Japanese word for cat, **neko**, also is used as a name for such characters.

STATS		
EYES	She's usually meant to be cute; large eyes come standard.	
NOSE	It can be more human, but more often it resembles a cat's.	
EARS	The position of the ears also can vary. Sometimes they come out from the usual place, but typically they are mounted higher up on the skull.	
BODY	The body usually takes a human form, but with the addition of a tail. Think of the bones in the tail as a graceful extension of the spine. It's fun to try out different animal patterns when coloring the skin. This is a creature of pure fantasy. Feel free to experiment.	

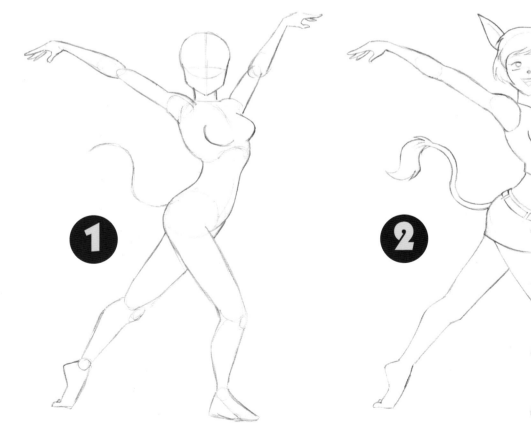

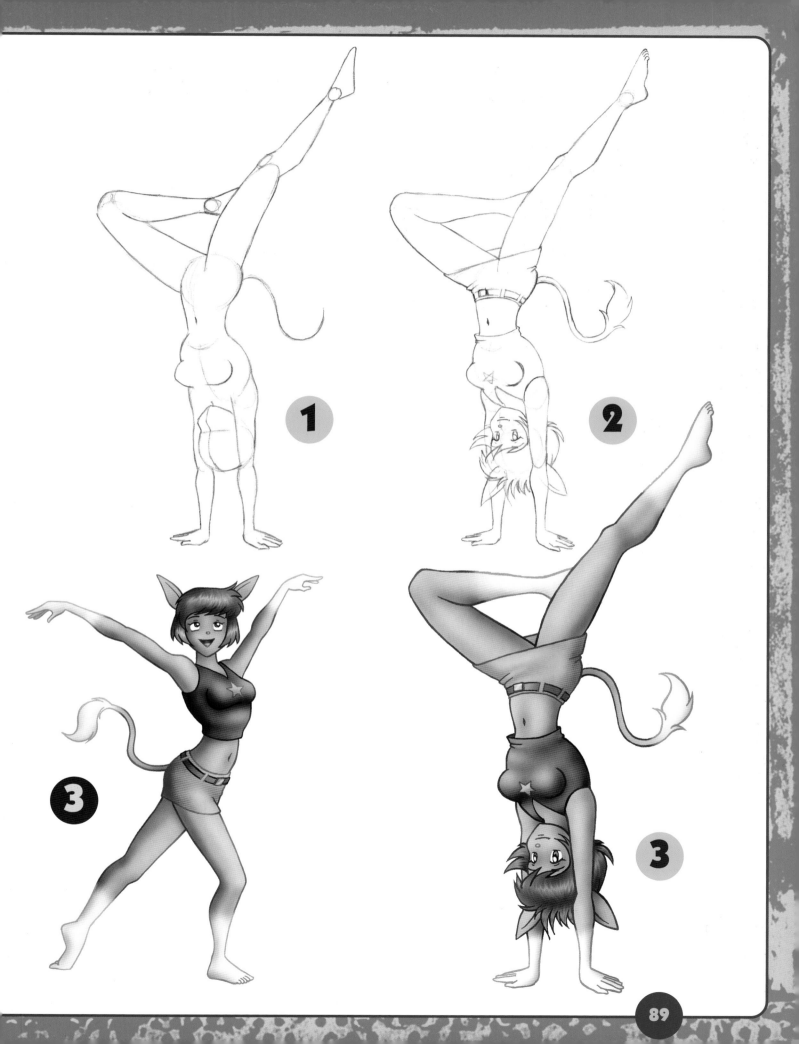

Rotation Gallery

Here is a group of character rotations. Each character is shown in the same pose and from four different views: front, profile, three-quarter front and three-quarter back. The horizontal lines illustrate how many heads tall the character stands for purposes of proportion. Drawings like these give an artist an idea of how a character looks so he or she can draw it from any angle and in any pose.

We have explored many techniques used by manga and anime artists to create great drawings. I hope my instruction has been of some help to you; however, there is only so much one can learn from any book. In the art of drawing manga, the best teacher will be your own eye. Keep looking at real life, for inspiration, and try to recognize how it translates into your own style.

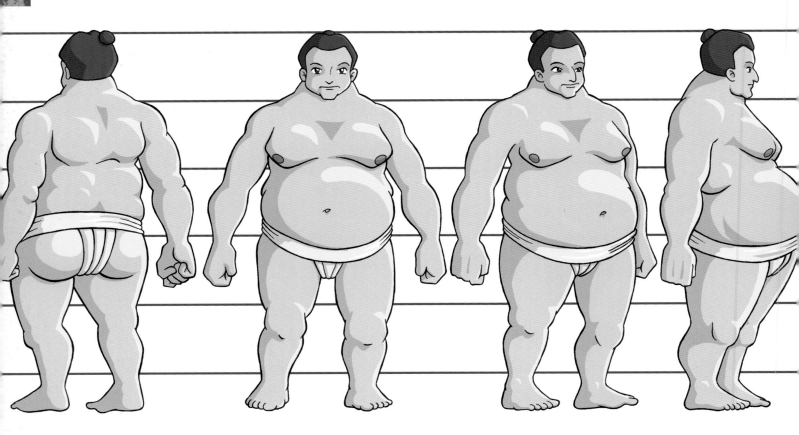

Sumo Wrestler

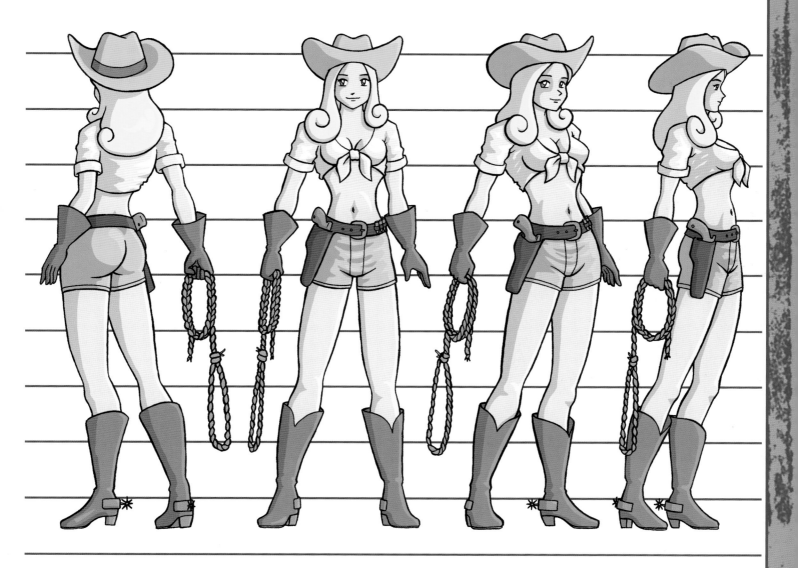

Cowgirl

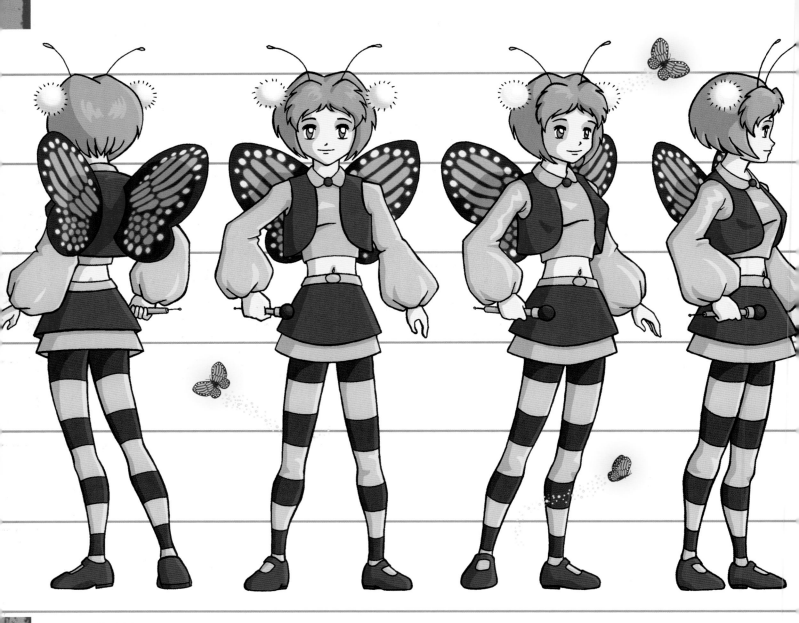

Butterfly Girl

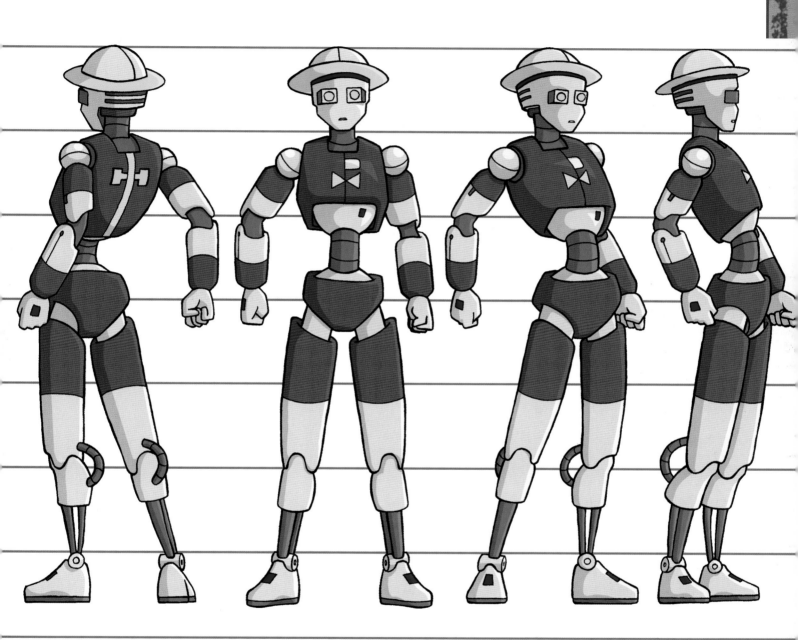

Robot

Index

GOOD BOOKS

For figure drawing:
Constructive Anatomy *by George B. Bridgeman, ISBN 0-486-21104-5*
Figure and Form *by Lu Bro, ISBN 0-697-03059-8*

For perspective:
Perspective Made Easy *by Ernest Norling, ISBN 0-486-40473-0*

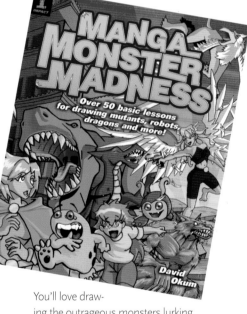